INTERNATIONAL ENCYCLOPEDIA OF ART

African Art

first edition

William R. Rea

☑®

Facts On File, Inc.

INTERNATIONAL ENCYCLOPEDIA OF ART
AFRICAN ART

Text copyright © 1996 William R. Rea
Copyright © 1996 Cynthia Parzych Publishing, Inc.
Design, maps, timeline design copyright © 1996 Cynthia Parzych Publishing, Inc.

Cataloging-in-Publication Data available on request from
Facts On File, Inc.

This is a Mirabel Book produced by:
Cynthia Parzych Publishing, Inc.
648 Broadway
New York, NY 10012

To V.A.S.

Edited by: Frances Helby
Designed by: Dorchester Typesetting Group Ltd.
Printed and bound in Spain by: International Graphic Service

Front cover: Zinc brass Ife figure
of a king, twelfth to fifteenth century A.D.

10 9 8 7 6 5 4 3 2 1

Contents

Introduction ..5

1 The Art of African Prehistory10
2 Egypt and Meroë ...14
3 Sculpture in Sub-Saharan Africa, 500–1000 A.D.16
4 The Development of Towns in Africa, 800–1300 A.D.20
5 Sculpture in Nigeria, 1000–1500 A.D.22
6 Empires of Ethiopia, 600 B.C.–1900 A.D.26
7 Benin and Asante, 1500–1800 A.D.28
8 Africa and the World, 1300–1700 A.D.32
9 Empires of the Forests ..34
10 The Yoruba ..38
11 Art and Ancestors ..42
12 Secret Societies and the Art of the Mask44
13 Body Art ..48
14 Textiles ..50
15 Arts of Southern Africa, 1700–1900 A.D.52
16 Arts of the African Diaspora54
17 International African Art58

Bibliography ..60
Glossary ..61
Photo Credits ..62
Index ..63

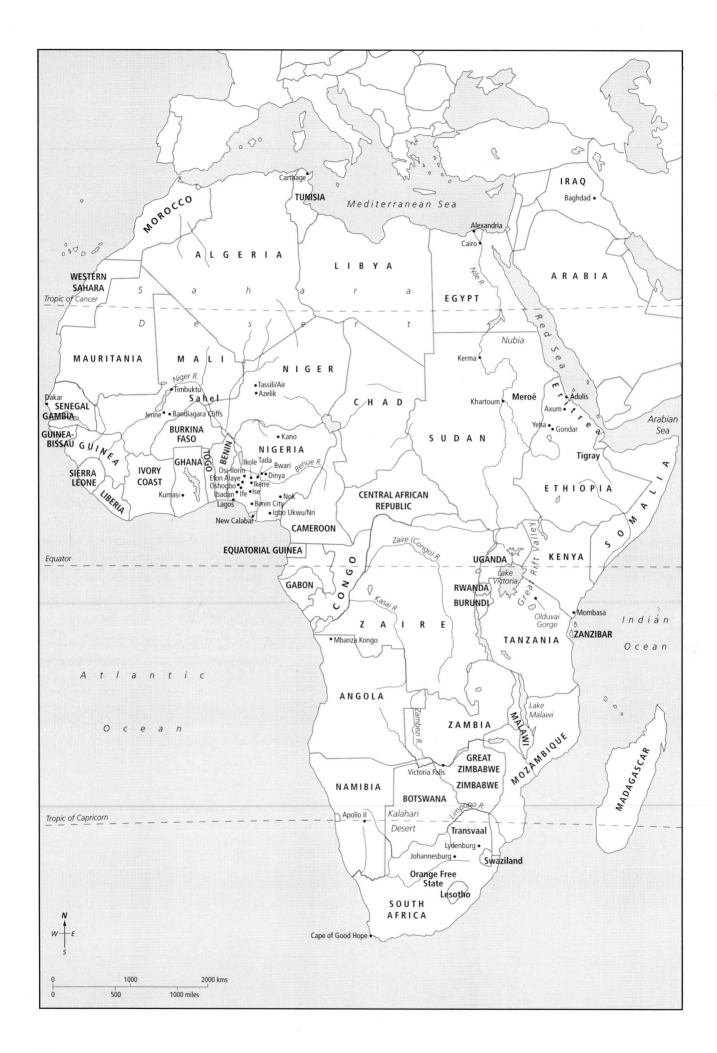

IRAQ
Baghdad

TUNISIA
Carthage
Mediterranean Sea

MOROCCO

Alexandria
Cairo

WESTERN
SAHARA
Tropic of Cancer

ALGERIA

LIBYA

EGYPT

ARABIA

Nile R.

MAURITANIA

MALI

NIGER

CHAD

S a h a r a D e s e r t

Nubia

Red Sea

*Arabian
Sea*

Kerma

Khartoum

Meroë

Adulis
Axum
Yeha • Gondar

Niger R.
• Timbuktu
Sahel

Tassili/Air
Azelik

SUDAN

ERITREA

Dakar
SENEGAL
GAMBIA
GUINEA-
BISSAU
GUINEA

Jenne • Bandiagara Cliffs

BURKINA
FASO

SIERRA
LEONE
LIBERIA

IVORY
COAST

GHANA

Kumasi •

BENIN
TOGO

Kano •

NIGERIA

Ikole Tada
Osi-Ilorin Bwari
Eton Alaye • Dinya
Oshogbo • Ikerre
Ibadan • Ife Ise
Lagos • Benin City
• Igbo Ukwu/Nri
New Calabar

Benue R.

Nok •

Tigray

ETHIOPIA

SOMALIA

CENTRAL AFRICAN
REPUBLIC

CAMEROON

EQUATORIAL GUINEA

Equator

GABON

CONGO

Zaire (Congo) R.

UGANDA

KENYA

Kasai R.

Z A I R E

RWANDA
BURUNDI

*Lake
Victoria*

Great Rift Valley

• Mombasa

*Olduvai
Gorge*

TANZANIA

ZANZIBAR

*Indian

Ocean*

• Mbanza Kongo

*Atlantic

Ocean*

ANGOLA

ZAMBIA

MALAWI

*Lake
Malawi*

MOZAMBIQUE

MADAGASCAR

Zambezi R.

GREAT
ZIMBABWE

Victoria Falls

ZIMBABWE

NAMIBIA

BOTSWANA

Tropic of Capricorn

Apollo II

*Kalahari
Desert*

Limpopo R.

Transvaal

Lydenburg

Johannesburg •

Swaziland

Orange Free
State

Lesotho

SOUTH
AFRICA

Cape of Good Hope •

N
W E
S

0 1000 2000 kms
0 500 1000 miles

Introduction

On the morning of February 18, 1897, the British army surrounded the city of Benin in southwestern Nigeria. The journey to Benin was long and difficult, through the thick rain forest of this part of the West African coast. Even in the best of times the journey was difficult, with travelers taking a boat ride up the sluggish Niger River and then hacking across country, through the mangrove swamps and along thin forest paths. This was not the best of times. The British army had set out to teach the people of Benin that challenging the British in Nigeria would mean instant punishment. The people of Benin, called the Edo, knew that the British were coming, and all along the route they had prepared ambushes and traps. In Benin itself the king (known as the Oba) made numerous ritual sacrifices to the gods of the Edo, begging them to protect him.

The sacrifices were no match for British weapons and by the evening the British had captured Benin and put the king of this once powerful state in chains. No West African empire would challenge British trade again. Yet this is not the end of the story. Oba Ovenramwen was exiled and his large palace taken over. The inside of the palace must have filled the British troops with wonder. Rooms were packed with stacks of brass plaques depicting

Timeline

This timeline lists some of the important events, both historical (listed above the time bar) and art historical (below) that have been mentioned in this book. While every event cannot be mentioned it is hoped that this diagram will help the reader to understand at a glance how these events relate in time.

1,700,000: Hunters and gatherers live in East Africa in the Paleolithic period.

1,700,000 B.C.

1,700,000: The first cultural artifacts, tools, are made in Tanzania.

23,000: The San civilization of hunters and gatherers thrives in southern Africa.

27,500–25,500 B.C.

27,500: The first paintings are made by the San people in southern Africa in the Apollo II cave in Namibia.

about 6000: A civilization of hunters and gatherers thrives in the Sahara.

about 5000: Early farming communities are set up in Nubia and use the Nile to irrigate crops.

about 4000: Pastoralists begin to domesticate cattle and live in villages in the Sahara.

3100: People of Nubia become united into a chiefdom.

6000–3100 B.C.

6000: Bubaline period rock paintings are made at Tassili in the Sahara.

about 4000: Bovidine period rock paintings are made in the Sahara.

scenes from Edo life. In the inner courtyards of the palace the troops found altars on top of which were carved ivory tusks, wooden sculptures and most importantly a series of bronze heads that were so well made that few in the British party could believe that they were made by Africans.

As they explored Africa, Europeans increasingly came across cultures that produced rich and diverse art forms. Many nineteenth-century Europeans found it hard to understand these objects as art because they were very different to what Europeans were used to seeing in their museums and galleries. European art in the nineteenth century was still based upon the proportions of the human body derived from classical Greek sculpture. African art looked very different. Europeans thought of many of the objects as evidence of a more "primitive" way of life, particularly of a more primitive religion. This way of thinking suited missionaries,

traders and eventually colonial powers who argued that Africans were undeveloped and needed "civilizing". Even when Europeans could understand the art because it was naturalistic like that of Benin and Ife sculpture, or monumental like Great Zimbabwe, they claimed that this was evidence of Egyptian or external colonization in Africa.

Attitudes of people from outside Africa to African art changed slowly. The biggest change occurred when artists from Europe were introduced to African art. Painters such as Pablo Picasso (1881–1973) and Amedeo Modigliani (1884–1920) saw African art in Paris at the turn of the century and immediately realized that its form and imagery could be used to transform conventional attitudes toward art and the way in which the human body was represented. Many of the artists in Paris in the early years of the twentieth century collected and used sculpture from Africa, which was imported into Paris by returning

about 2700: Pastoralists begin to use horses to herd their cattle in the Sahara.

1650: The first Nubian city, Kerma, is built.

1400: Egypt takes control of Kerma for about 400 years.

1000: The Napata kingdom rises and replaces Egyptian rule in Nubia. Communities along the Niger River grow cereal crops, herd animals and people begin to live in villages.

2700–1000 B.C.

2700: Charioteer period rock paintings are made in the Sahar.a.

2700: Copper is smelted in Azelik in Niger.

1700: Kerma pottery is made of fired clay.

750: Camels are introduced to Egypt.

747–656: The Napata kingdom controls Egypt.

about 500: People begin to move from the Sahara region as the desert becomes drier. Ethiopian culture develops as farm communities form.

500–400: The Meroë kingdom becomes powerful and controls the Nile River.

about 300: Arabs begin to trade with African east coast settlements. Bantu-speaking people migrate from Nigeria and Cameroon to Lake Victoria and then to Zimbabwe carrying iron-making and farming skills.

750–300 B.C.

about 600: In the Ethiopian town of Yeha, temples and palaces are built and bronze objects are produced.

about 500: Camelid period rock paintings are made in the Sahara. Iron-making Nok communities make pottery sculptures in central Nigeria.

500–400: The Meroë kingdom employs Greek architects to build the city in a Greek Hellenistic style that also incorporates Egyptian symbols.

about 300: The Swahili language and architecture style develop in east coast Africa.

1–400: Ethiopian town of Axum becomes powerful due to trade.

50: Ancient Jenne is occupied by farmers.

190: Christianity spreads throughout the Mediterranean and a Christian monastery is set up in Alexandria, Egypt.

300–500: The people of Axum become Christians.

1–499 A.D.

1–400: Stone monuments are built at Axum.

190–642: Coptic Art flourishes.

colonial officers and collectors.

Europeans also changed their attitudes as they became more familiar with the various peoples of Africa through the work of anthropologists. An anthropologist goes to live in a group of people and shares in their daily life in order to get to know why they do things that are puzzling to people from other cultures. Throughout the twentieth century European and American anthropologists have been going to live in African towns and villages. (Today, they often study European and American ways of life too.) Through their work people outside Africa began to understand the role of art in the society, why it had a specific purpose, why it was made in a particular way and whether it was regarded as beautiful by the people themselves.

Nowadays the arts of Africa are understood by people in the rest of the world to be as much a part of world civilization as any other arts. Attitudes have been altered by scholars and by artists themselves. There are few Europeans or Americans left who claim that the art of Africa is not African, but brought there from somewhere else, or who claim that it is primitive and less developed than European art. Change in Africa, like change in the rest of the world, is shown in the type of art that is produced, as well as in the subject matter that artists choose to represent. The carver who would once have carved an important chief riding a horse now shows him in his car. There are now a number of flourishing art schools. Students are encouraged to explore their own traditions and they are given a classical European training in art as well. The way African art is viewed by Europeans and Americans today is very different to the way the men who looted Benin saw it.

The story of art in Africa is the longest in world history but it is one of the hardest in the world to

by 500: Bantu-speaking people migrate and bring metal-working skills to South Africa.

642: Islamic armies invade Coptic Egypt and it becomes an Islamic province for 300 years.

about 800: Towns begin to develop in Africa. The people of Igbo Ukwu live in a large city ruled by a king. Jenne grows to a city of 10,000 inhabitants due to trade.

969: Egypt gains independence from Baghdad when the Fatimids take control of Cairo.

500–999 A.D.

500–700: The Lyndenburg pottery heads are made in South Africa.

about 600: First African coins are made at Axum.

about 800: Trade guilds work at Jenne in leather, pottery, gold and other metals. Sculptors at Igbo Ukwu use lost-wax casting to make bronze heads and other objects.

969: The Fatimids begin to rebuild Cairo and create great mosques.

1000: Cities of Jenne, Ife, Timbuktu and Great Zimbabwe grow. Trade becomes important in the Sahel.

about 1200: Islamic states develop in the Sahara. The Kongo empire is established.

late 1200s–early 1300s: City of Benin is founded. Ife civilization reaches the height of its power.

1472: The Portuguese become the first Europeans to reach Benin due to new developments in sailing ships and establish trade ties.

1484: The Portuguese reach the Kongo empire.

1497: Vasco da Gama sails around the Cape of Good Hope to India.

1000–1499 A.D.

1000–1500: Metal sculpture is produced in Nigeria at Igbo Ukwu, Ife and other cities using lost-wax casting.

about 1100: First large walls are built at Great Zimbabwe.

1200–1300s: Architecture of the Sahel is built in the Islamic style.

1200–1400: Soapstone birds are carved at Great Zimbabwe.

about 1250: The largest stone monuments in Africa are built at Great Zimbabwe. Some still stand.

1400–1500s: Benin artists, working in guilds, make bronze and ivory objects.

by 1500s: Asante power grows as Akan states unite to increase agriculture and engage in trade in gold. Benin empire controls all of southern Nigeria and conquers many surrounding people.

about 1600: The Kuba kingdom is created by Shayaam aMbul a Ngoong. The capital of Christian Ethiopia moves to Gondar.

1660: War breaks out between the Portuguese and the Kongo over trade.

early 1700s: Kongo state collapses and the Kuba and Luba become powerful. Slavery system spreads to the U.S.

1701: The Asante confederation is established. The golden stool is said to have descended from heaven.

1500–1799 A.D.

1500s–1700s: Kongo artists make *mintindi* stone figures.

1598: Cornelius Hautman makes the first known painting of the Cape of Good Hope.

1600s: Palace walls of Benin are decorated with brass plaques containing Portuguese figures.

1600–1700s: Kuba artists make *ndop* figures.

1658: Walter Shouten paints the first reliable interpretation of Table Mountain.

early 1700: Luba artists make bow stands and other objects. African slaves in the U.S. make naive paintings.

understand. For many years the colonial powers in Africa maintained the idea that Africa had no history. It suited them to portray Africa as a backward place that it was their job to civilize. This was not the truth. Any society or culture that has been in a place for any length of time has a history. The difficulty of African history and the place of art in that history is to find out about it.

The biggest problem in finding out about African art history is that many African societies relied upon the spoken word. In Europe and America, historians or art historians can go to archives and libraries and look at books and papers written at the time they are studying. This is not possible in Africa because until recently only rarely did people in many African cultures write anything down. Instead of writing many peoples relied upon story telling to remember important events. This type of culture is called an oral culture because the spoken

word is most important. Stories are kept in memory and handed on from generation to generation. The problem is that not everything is remembered, things get forgotten and sometimes the speaker will change things just to make something stand out in people's minds. Often the person who has the information may die before it is handed on.

If all we wanted to know about African art was the way it looked, then there are plenty of examples of African art in museums in Africa and around the world. The artists in Paris in the 1900s wanted to see the effect that African art had upon their own work. They did not care where it came from, what it was used for or why one work looked like another. This is quite a good way of looking at art, but it does not tell us much about the object.

All art historians, whether studying European, African or any other kind of art, need to look at

1910: South Africa is declared a country: The Union of South Africa.

by 1914: Africa is under the imperial rule of European powers.

by 1920s: The "New Negro" movement is stimulated by World War I and the migration of southern blacks to northern cities.

1945–50s: The movement begins to grow to remove colonial rule.

1948: The Nationalists come to power in South Africa and the system of Apartheid is set up.

1800s: The British occupy the Cape Colony.

1860: The Republic of South Africa is formed.

1884–85: The Berlin Conference is held to divide African territories among European powers.

1899–1902: The Boer War.

late 1800s: Slaves begin to return to Nigeria from Brazil after slavery is abolished.

1970s: Apartheid movement is actively challenged by South African blacks.

1977: The leader of the Black Consciousness Movement, Steve Biko, is murdered.

1994: Nelson Mandela becomes president of South Africa and Apartheid is abolished.

late 1900s: Dinka and Massai pastoralists continue to live in East Africa.

1800–99 A.D.

1900–1949 A.D.

1950 A.D.–present

1800s: The number of professional artists working in South Africa increases.

1833: William Bowler, a watercolorist, arrives in the Cape Colony and becomes one of the first painters to teach art.

late 1800s: Returning slaves bring a Portuguese–Brazilian style of architecture to Nigeria and other Yoruba areas.

early 1900s: Some African artists begin to receive formal training.

by 1920s: The Harlem Renaissance results in a blossoming of all the arts in Harlem in New York.

1931: Art schools develop in Nigeria. The Leakeys discover the first stone handaxes made by man.

1948: Polly Street Art Centre is set up in Johannesburg.

1960s: Ulli Bieir starts art workshops in the Yoruba town of Oshogbo.

1970–1990s: Contemporary artists find a market for their work in Africa and begin to exhibit internationally.

how an object is made and used in society. This way of looking at art was very popular among European and American historians of Africa in the first half of the twentieth century, because many of them were trained as anthropologists. But it meant that art was seen as being only functional, that is, something to make a society work better. The anthropologists were not looking at how people saw their own works of art. Nowadays, people studying African art history have learned to look at the way an object is used in society, and are often concerned with its meaning, but they also look at the feelings that the people have toward the objects that they make.

Africa is the second largest continent with numerous different climatic and vegetation types. It lies across the two tropics with the equator running roughly through the middle. The climate and vegetation can be divided into three general types which are tropical, sub-tropical and temperate.

A belt of Mediterranean vegetation runs around the top rim of the northern part of the continent. This merges into the Sahara desert. To the south the Sahara gives way to an area which is called the Sahel in West Africa and the savanna in East Africa. This is an area of mixed scrub, small trees and grasslands. It produces a number of different grains and, in the east supports a large number of wild animals. Near the equator the climate becomes humid. This is particularly true in West and Central Africa. In the west the Sahel stops about 160 miles/320 kilometers north of the coast and the small trees are replaced by increasingly thick rain forest. The central area of Africa is almost completely covered with rain forest. However East Africa is on higher ground and the cooler climate allows the savanna to survive.

South of the equator the climate is a mirror image of the north. The scrub forests briefly reappear, but are replaced by the dry deserts of the south, especially the Namib desert in the southwest. At the very southern tip of the continent, around the Cape of Good Hope a Mediterranean-style climate reappears.

The climatic types and associated vegetation have had an effect upon African societies and the types of art that they produce. Geographical features may determine the overall pattern of social organization. The different types of vegetation have had a major effect upon communication between the different regions of the continent, and between Africa and other parts of the world.

The Sahara has had a major influence on Africa's relations with other parts of the world, as well as on internal African relations. The region has not always been desert, and in the past there have been many different trading relations between North Africa and the peoples of the West African region. The Sahara gradually became more and more arid and difficult to cross, although trade caravans never gave up. South of the Sahara the rain forest has always prevented easy travel. Few large roads could be made through the heavy vegetation before the invention of big machines, and the existence of the disease-carrying tsetse fly in this region meant that large domestic and transport animals such as the horse could not survive.

Apart from vegetation types other factors have affected relationships between Africa and other parts of the world. The seas around Africa have been used by outsiders for many years. The Arabs have a long history of using the east coast sea routes in the Indian Ocean. However, the prevailing currents in the Atlantic meant that it was not until changes in seafaring technology developed in the fifteenth century A.D. that Europeans were first able to contact the Atlantic coast of West Africa.

The Art of African Prehistory

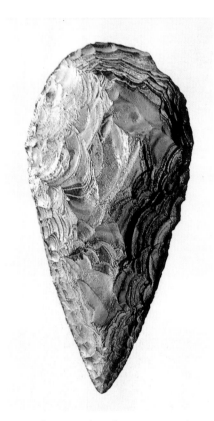

▲ *By the time this object was made about 600,000 years ago, technology had advanced. This South African stone handax was probably never used for cutting, but would have been a prestige item. This shows that early modern people understood the value of a beautiful object.*

The first art in the world was made in Africa. Two million years ago, in a time called the Paleolithic period the first human beings were walking in the plains of East Africa. Paleolithic people were the first to make tools deliberately. They used the things they found around them, such as wood and stones, and shaped them into useful objects.

Tools left by the earliest human beings give clues about the way they lived. By looking at their tools archeologists can see that they were preparing and sharing their food, so they must have been living in social groups or societies. This means that the earliest people must have had a language so they could talk to each other. Archeologists think early man developed language and tool-making at about the same time.

These people did not grow their own food, but gathered and hunted it. All members of a community cooperated to bring food to a central camp; some gathered roots, berries and leaves and some hunted for meat. In Africa there are still groups of people living by hunting and gathering. These people are called the San and live in southern Africa. Their ancestors made the first paintings in Africa.

The first paintings in Africa were made long after the first tools. The San painted them in caves over 25,000 years ago, at about the same time as cave paintings were made in Northern Europe. The earliest African paintings were found in a cave known as Apollo II in Namibia. They show animals such as the giraffe, and figures that are half animal and half human. The artists probably painted these figures because they believed human beings could change into animals. Perhaps they believed that when a human being changed into an animal the spirit of the animal could be used for healing the sick.

The First Things People Made _____

Tools made from stone are the oldest objects that can be properly called cultural artifacts. The earliest tools in the world were made in Tanzania. In the Great Rift Valley rivers have eroded the land leaving ancient areas exposed. The archeologists Louis (1903–72) and Mary (1913–) Leakey worked in the Olduvai Gorge area of the Great Rift Valley for fifty years and discovered many fossil remains of early human beings, including early skulls. They knew that this was an important area of human habitation even before they found any fossils because, in 1931, they discovered the first stone tools. These were handaxes which are pieces of stone that have been chipped, or knapped, using either a piece of bone or another stone, to make tools. Flakes of rock were removed so that sharp edges were left on the sides of the stones. These stone tools were used for cutting through meat or bone, for preparing skins to be worn, and even for grinding berries. ■

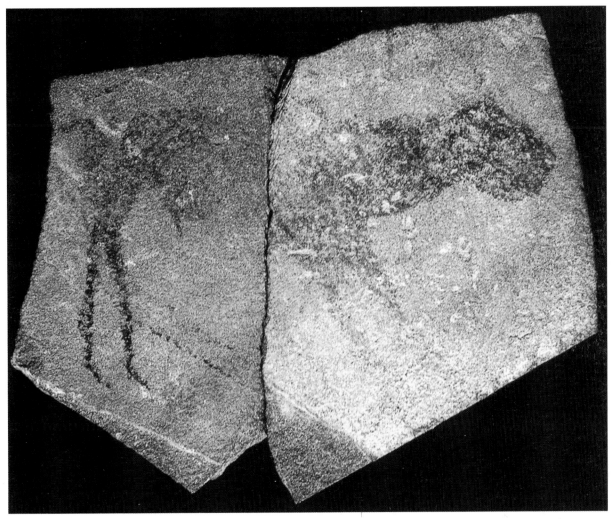

▲ *The charcoal drawing of an animal, an antelope, shown here, is the earliest work of art known to mankind. It was drawn on the stone walls of the Apollo II cave in Namibia between 27,500 and 25,500 years ago.*

Who Were the First Human Beings?

The name given to the first human beings is *Homo habilis*. This means handyman, or tool-making man. They were the first tool-making people. They were shorter than modern human beings and had a smaller brain size. They did not wear clothes and were covered in hair, but their faces were similar to modern people's. *Homo habilis* lived in groups and they shared food and cared for their children until they were able to feed themselves. ■

Rock paintings are also found in the Sahara desert. These paintings were made much later than the southern African ones, beginning around 6000 B.C. The best known paintings of the Sahara come from a place in the middle of the desert, called Tassili, and were only recently discovered by Westerners.

The paintings at Tassili are on large cliffs. They range in size between miniatures and paintings more then ten feet/three meters high. Many colors are used: deep red made from iron oxide, yellows and greens from copper oxides and white from kaolin (a kind of clay). They show many species of animals.

Because of the kinds of animals painted in the different paintings it is possible to divide up the paintings into separate periods. Some of the paintings show animals which can live in a certain climate. Others show animals which live in another climate. All the paintings are of animals living at Tassili, so the

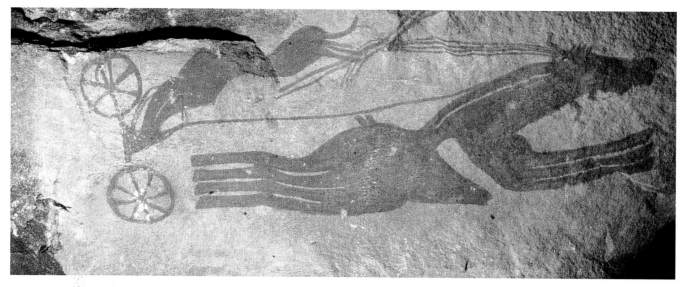

▲ *This Tassili rock painting of about 2700 B.C. is from the Charioteer period. The driver rides in a two-wheeled chariot pulled by horses that appear to be rushing forward at a flying gallop.*

San Paintings

The paintings of the San people depict scenes of hunting and gathering. Men and women are shown going about their daily routine, and some scenes show great hunting expeditions. Human figures are painted close to antelopes, elephants and lions in great scenic views. The most important animal in the paintings is the eland, a type of antelope. ■

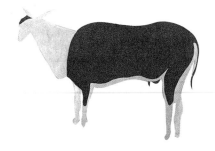

▲ *This is a San wall painting of an eland. The eland, a type of antelope, is the most important animal in San religion.*

climate must have changed between one set of paintings and another. They must have been painted in different periods.

The first period, the Bubaline, is named after the bubalus, the animal that is most commonly painted. The bubalus was a type of antelope that is now extinct. The paintings show an antelope with large curving horns, not seen on any antelope today. Elephants, hippos and ostriches were also painted in this period in massive paintings covering the rock walls. It is clear from these paintings that the Sahara was a lot wetter then than it is now, or these animals would not have been able to survive there. Human figures carrying various sorts of weapons also appear among the paintings of animals. They were probably hunters. The artists paid attention to the detail of the animals' biological features which are very lifelike. They are so carefully drawn that modern-day biologists can distinguish between species.

The earliest people in the Sahara were hunter-gatherers. Then the Sahara started to dry out and the number of cattle increased. The people's way of life had to change and they began to live in village settlements. They no longer gathered and hunted their food but kept their animals with them as they moved from place to place. People who keep cattle or sheep are known as pastoralists.

There are more cattle shown in the paintings from about 4000 B.C. and this time is known as the Bovidine period (bovine means having to do with cattle). Wild animals were still painted but there were fewer of them in the paintings and finally only elephants were left. There were also changes in the way that artists drew animals. They paid much less attention to detail so, for example, a cow would be shown only by a simple mark, a line or curve. These marks are called pictographs, and may have been the first writing in Africa.

The Bovidine period ended about 2700 B.C. People continued to herd cows but now they did it on horseback. The first horses were

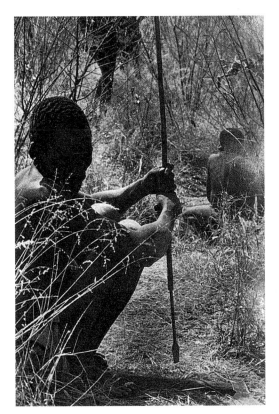

▲ *The San are still very expert hunters and have a great knowledge of their environment.*

Shamanism

Shamanism is the belief that human beings can turn into animals. Only important people called shamans, probably priests, are thought to be able to transform themselves. They do this by going into a trance and forgetting that they are human. Sometimes they even dance around with other people, imitating the movements of an animal. ■

introduced to the Sahara from the Mediterranean by the earliest Egyptians, who had tamed the wild Arabian horse. This time is called the Charioteer period. Paintings of this period show wild horses running freely in herds, but they also show individual riders on horses, herding their cattle. The arrival of horses also meant that a different sort of transport could develop. The horse drawn chariot was invented in this period. It is not clear whether the chariots were used for war or for herding animals, but they would have been very useful for both. The paintings of the Sahara show chariots, painted as though the artist was looking down on them and the horses from above, a type of drawing called a plan view.

The fourth period, called the Camelid period, of Saharan rock art dates from 500 B.C. The climate was clearly changing. The Sahara became drier and drier and it became more difficult for people to live there, so there are fewer paintings from this period. There are no more wild animals in the paintings. Even horses could not survive. The only animal shown is the camel. Camels were introduced into Egypt at about 750 B.C. from the trade routes across the Middle East. They quickly replaced horses as beasts of burden and were to remain the most important tool of trade in Africa until the Europeans sailed down the coast in the fifteenth century A.D.

Pastoralists

There are still pastoralists living in Africa today. In East Africa the Dinka and the Massai peoples live surrounded by their cattle. They often have villages but they only go to them at certain times of year. They spend most of the time moving with their cattle in search of food. They do not have much art, because to these people their most beautiful objects are their cattle. ■

This recent photograph shows a Dinka ▶ *pastoralist with his ox. He has decorated the ox's horns to make them beautiful.*

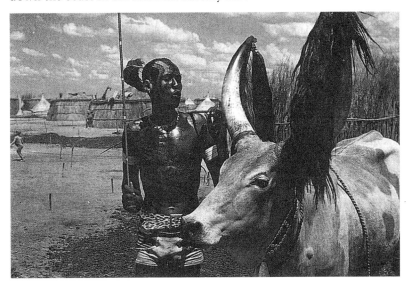

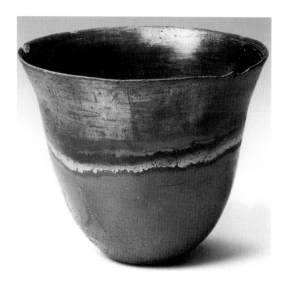

▲ *This Kerma drinking vessel was found buried with a wealthy man. It was made of fired clay between 1750 and 1550 B.C.*

Kerma Pottery

The greatest achievement of Kerma art was its pottery. The pots are very thin and elegant and are often shaped like drinking vessels. They are decorated in a red glaze often with a grey line running around the middle. Their delicacy indicates that they were made by specialists for the king and the royal court. ■

The great empires of Egypt grew out of the small farming communities of the Sahara. As the Sahara became hotter and hotter and dried out, many of the people there were forced to look for a reliable source of food and water, and they found it in the Nile River. Even at their strongest the Egyptians still placed a high importance upon the Nile, and its seasonal rise and fall. The Egyptians were not the only people who used the Nile. The Nile flows north though Africa to Egypt, and higher up the river African civilizations formed along its banks.

The greatest of these were the Nubian city kingdoms which formed to the south of Egypt in what is now Sudan. These kingdoms were fierce opponents of the Egyptians, but even so they were influenced by Egyptian religion, art and culture.

The earliest inhabitants of prehistoric Nubia settled there between 5000 and 4000 B.C. They were farmers who used the Nile to irrigate their crops. In 3100 B.C. the people of Nubia united into a chiefdom, whose rulers used Egyptian symbols of power, such as the royal maces. They also learned building skills from the Egyptians.

It was not until 1650 B.C. that the first great Nubian city was built: the city of Kerma. Kerma was surrounded by a huge wall over thirty feet/ten meters high. There were four grand gateways in the walls. In the center of the city stood a palace and a monumental temple. These were the most important buildings and show that the people living in this town were ruled over by a king who was seen as a god. Royal burial sites show that the king was buried surrounded by hundreds of his attendants. They were buried with the king because he would need them in the world of the dead.

Eventually the kingdom of Kerma grew so powerful that in 1400 B.C. the Egyptians sent an army to defeat it. For the next four hundred

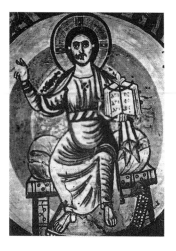

◄ *This Coptic fresco is of Christ in heaven. He is in his full glory, showing the New Testament to his followers. It was painted in a niche in the monastery of Bawit in about 478 A.D.*

Coptic Art

In the years following the crucifixion of Christ in about 30 A.D. the Christian word spread throughout the Mediterranean. One area where it gained hold was Egypt. By the year 190 A.D. a monastery and school had been set up in Alexandria. The Christians suffered persecution under the Romans in Egypt but found life easier than in Rome. Coptic art, which flourished from 190 to 642 A.D., combined influences from Egyptian painting and from Greek art. ■

Later Egypt and Africa

In 642 A.D., Coptic Egypt was invaded by Islamic armies. For 300 years it was a province of the Islamic empires based in Baghdad to the east. There was little building at this time, and the Christian and Jewish influences were still important in the art of the area. In 969 A.D., Egypt gained its independence from Baghdad, when the Fatimids from North Africa gained control over Cairo.

The Fatimids rebuilt Cairo. Some of the great mosques in the city today date from the Fatimid dynasties. There was great wealth in Cairo. The kings built pavilions of gilded marble and ornate gardens. Some of the fantastic riches survive, including carved rock crystals and embroidered textiles.

The Fatimids and their successors, the Mamluks, were influential in extending the influence of Islam into Africa. These dynasties overwhelmed the Berber peoples of North Africa and introduced the Koran to the Sudanic regions. Many of these Korans are beautiful works of art. ■

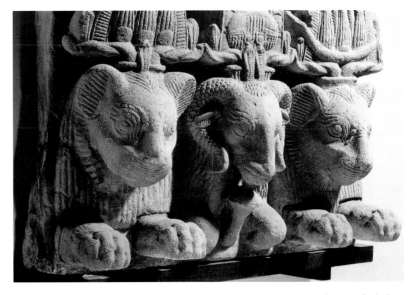

▲ *The central head of this sandstone panel is of the ram, the symbol the Meroë used for the god Amun. The ram has lions at either side. They could be the symbols of the lion-headed man Apedemak and the moon god Khonsu. This panel comes from the Lion Temple of Musawwarat, built by the king, Amekhamani, a contemporary of Ptolomy IV in Egypt, in about 200 B.C.*

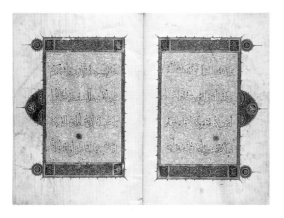

▲ *This is the earliest Mamluk Koran, the holy book of Islam. It was produced by Ibn al Wahidin, one of the greatest Koran makers. The words are the words of god, and so important that they are made in gold leaf on parchment.*

years the Nubians were under Egyptian control, but by about 1000 B.C., however, Egypt could no longer control its southern neighbor, and a new Nubian kingdom arose.

The kingdom that replaced the Egyptian rulers in Nubia was called Napata. This kingdom grew so powerful that later it took control of Egypt. This time is known as the Napatan period and lasted between 747 and 656 B.C. It was during this period that the styles of Egyptian art had the greatest effect upon what was made in Nubia. Egyptian even became the language of the Napatans.

The greatest Nubian kingdom, Meroë, began to grow between 500 and 400 B.C. The city was located along the banks of the Nile, about two hundred miles/three hundred and twenty kilometers north of present-day Khartoum. Meroë was able to control the trade moving up and down the Nile between Egypt and the rest of Africa, and grew so powerful that even the Greek historian Herodotus (485–425 B.C.) mentioned it in his writings. We know from his histories that the rulers of Meroë employed Greek architects and parts of the city were built in a Greek Hellenistic style.

The most important buildings in the city were the palaces of the kings and the temples of the gods. Temples dedicated to Nubian gods and others to Egyptian gods, such as Amon and Isis were built. Egyptian symbols, such as papyrus plants and the disk of the sun placed above the heads of the gods, decorated many of the statues.

3 Sculpture in Sub-Saharan Africa, 500–1000 A.D.

The plow has never been used in traditional ▶ *African societies. This is because forests make it difficult to plow and the topsoil wears away very quickly. Instead African farmers have always used hand-held hoes to grow their crops in between the trees. The hoes are usually forked sticks, each with a flat piece of metal, with which the farmer can turn the topsoil.*

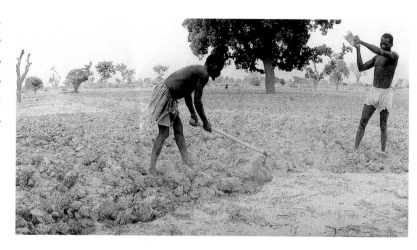

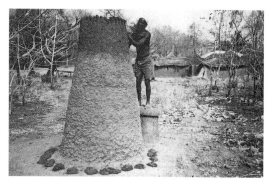

▲ *This picture shows the construction of an iron-working furnace in Banjeli, in northwestern Togo. It is called a natural draft furnace.*

Villages and towns that produced their food by farming did not grow only in Egypt and Nubia. The Nile became important to Egypt because the Sahara desert had become drier and drier. In the Sahel to the south of the Sahara too the people were forced to find a source of water, and many settled along the Niger River. They began to domesticate the wild plants of sub-Saharan Africa and live in settled communities (sub-Saharan Africa is all of Africa south of the Sahara.)

These communities were not very large and, unlike Egypt and Nubia, they did not develop into empires. By 1000 B.C. the villagers of this region were growing cereal crops such as millet and some rice. They herded goats and cattle, but not a great many. Each village was probably ruled over by groups of elder men, who made judgments for

Copper or Iron?

Many experts have suggested that the first metal smelted south of the Sahara was iron. There is very little evidence that copper was produced there, and some people say that Africa moved from stone age technology to using iron, without using copper. In most other places in the old world, copper was made before iron. This is because copper is easier to make than iron. Once people learned to make copper it was then easier to make iron. Because it was thought that there was no early copper making in sub-Saharan Africa, experts believed that Africans learned how to make iron from Egypt, Nubia or from the Mediterranean town of Carthage. They were wrong. A recent discovery of pieces of smelted copper at a place called Azelik in Niger has shown that copper was made in Africa. The date of the earliest copper is 2000 B.C., about the same time as copper was made in Europe. Copper-making sites spread across the southern Sahara as the use of this metal became known. By 500 B.C. a number of different peoples produced the metal. Once people could make copper it was a short step to making iron. ■

The Dinya Head _____

Each of the heads in the Nok tradition is named after the place where it was found. The Dinya Head was discovered in 1954. It is life-size and has a distinctive hairstyle, shaped into buns around the face. It was probably a part of a highly impressive figure, which would have been about five feet/one and a half meters high. Many of the heads in the area have elaborate hairstyles, so perhaps they were representations of important people, probably represented in their ceremonial dress. Jewelry and even modeled fragments of cloth can be seen on some of these heads. Because only some of the heads are like this, while others are plainer, we can see that the society was divided into classes. There were wealthy people who ruled over the other farmers of the Nok area. ■

Metal Working _____

Metal-making only happens in settled communities because of the time, materials and technology involved. All metals come from ores. An ore is a mixture of materials, usually stones or clays, which contain the metal. The metal in an ore has to be extracted from the other materials. Heat is used to separate the metal from the ore. In Africa this is done in a pit furnace. This is a covered pit in the ground. Charcoal is placed in the bottom of the pit, and the top is covered with clay. The ore is put in the furnace and a process known as reduction occurs. At the end of a firing the structure is broken open, and the charcoal and the rest of the ore, called slag, are discarded. What is left is a lump of iron, known as the bloom. The bloom has to be beaten into shape by a blacksmith to make tools. ■

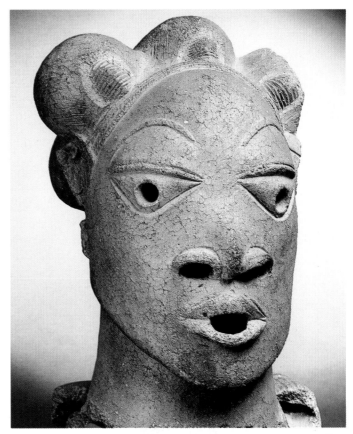

▲ *This is the Dinya head, one of the most famous of all Nok heads from Nigeria. It was made between 500 B.C. and 200 A.D. from fired clay and there are holes in the mouth and the eyes.*

everyone in the village. This may seem a very simple life, but the people of the Sahel made a discovery which changed sub-Saharan Africa forever. They learned how to make, or smelt, metal.

Making metal was one of the greatest technological revolutions of the ancient world. Metal is important to farmers because tools made from metal are much easier to use than those made from stone. They are harder wearing and less likely to break. The best metal for making tools is iron. Iron is hard enough to make tools but is soft enough when heated to be worked on by a blacksmith.

In these small iron-making communities lived the first sculptors in sub-Saharan Africa. The first sculpture-making people lived 2,500 years ago in an area of central Nigeria. These people are known as the Nok people. We know about them because in 1931 tin miners working at the village of Nok uncovered a pottery fragment of a human head. More pieces were found throughout central and northern Nigeria, often near to the tin mines. The sculptures have been found next to ancient iron deposits, so it is clear that these pottery sculptures came from the same ancient people who were smelting iron.

Evidence of ancient pottery and iron making are often found

together throughout Africa. This is because the processes of turning clay into pottery and smelting iron both rely upon the ability to use and control fire. Although people were making iron they did not know how to make sculpture from it. No iron sculpture has been found in the Nok region. All the sculpture that has been found is made in clay that has been fired, that is, baked using fire.

The sculptures made by the people of Nok and their neighbors in central Nigeria are remarkable for their detail. Almost all the sculpture that has been recovered is of human heads and figures. Some of the heads are life-size. The style of these sculptures varies from place to place, but they are all within the same tradition. All these sculptures have a number of features in common. All the heads are oval-shaped, and where full figures still exist, the head is proportionately bigger than the body. The eyes are almost always carved out of the clay as triangles. Sometimes the eyes are bulging from their sockets, and the eyeball is represented by a hole punched into the sculpture.

Some sculptures have been found showing human figures riding on horseback, and many of the full figure sculptures have their clothes modeled in great detail. They show that the people of Nok wore ornate robes and jewelry. It is possible that the sculpted figures are the kings and queens of the Nok people: they would have been the wealthy and powerful members of the Nok villages. It is, however, almost impossible to tell much about Nok society, as little evidence has survived. All that is left are the mysterious sculptures.

Nok is the earliest tradition of pottery sculpture in Africa, but not the only one. In South Africa people also made heads in pottery sculpture. These sculptures are known as the Lydenburg heads after the place where they were found. There are seven of them in all and they date from 500 to 700 A.D., considerably later than the Nok heads. The Lydenburg heads are also related to the early use of iron, as

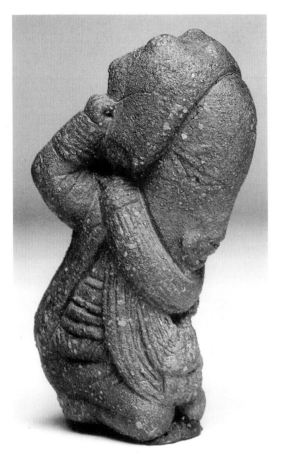

▲ *This small kneeling figure in fired clay was found at Bwari in central Nigeria. It was made in about 500 B.C. The head is much larger than the body, but the figure is dressed in fine robes.*

The Smith and His Wife

In many African communities there is a blacksmith, who knows how to make things out of iron. Inside a blacksmith's workshop is a furnace to heat up the iron and an anvil upon which he beats it out. In many places the blacksmith is seen as a dangerous man, controlling magical powers. He is often not allowed to marry a local woman because of this. In some communities the blacksmith's wife is always a potter from outside the society. ■

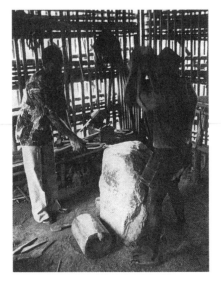

◀ *In this blacksmith's workshop in Cameroon you can see the stone that the smith uses as an anvil. He beats the iron out on it to make tools.*

This Lydenburg head was probably worn ▶
as a mask. It is big enough to wear over the
head. The mouth was used for the eyeholes so
the wearer could look out of the mask. It was
made of fired clay between 500 and 700 A.D.
Originally it was covered in a white pigment
to make it more dramatic.

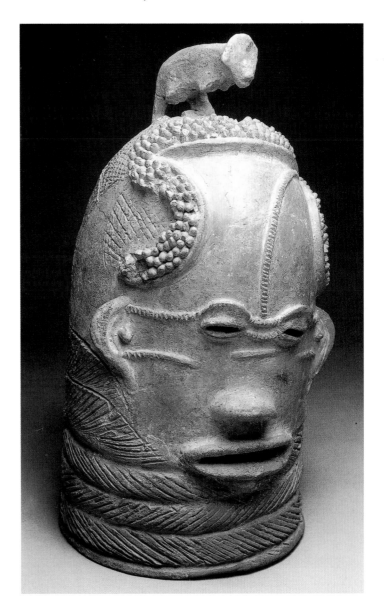

The Bantu Migrations

San bushmen, the people who lived in South Africa in the earliest years, were not the people who made the Lydenburg heads. The heads were found with charcoal nearby. Charcoal was used in iron-smelting furnaces and the San people did not make iron. The makers of the Lydenburg heads are more like the people of West Africa. In most of Africa, including southern Africa, people speak similar languages. The common name for all these languages is Bantu. Some archeologists believe that the peoples of sub-Saharan Africa all came from one location and that there was a migration of Bantu-speaking people throughout Africa. The migrating people carried knowledge about iron production and farming with them.

The location of the first Bantu people has been placed in southeastern Nigeria and Cameroon. From here the people spread in two directions, south and east. The eastern group probably moved around the rain forest, and reached Lake Victoria by about 300 B.C. and from here they moved southwards down the Great Rift Valley into Zimbabwe. The southern group moved more slowly through the forests into Zaire and Zambia. By the sixth century A.D. this group had brought their iron-working skills to southern Africa. ■

charcoal used in the furnaces has been found near them.

The heads were made like inverted pots, and two of them are large enough to be worn over someone's head. This means that they could have been used as masks to cover up the heads of dancers. The other heads have holes at the back of the neck which were probably used to attach them to a costume. All the heads have small eyes and wide mouths, and the mouths of the big heads are wide enough for a person to look through. Small pellets of clay on the larger heads indicate hairstyles. Small animal figures are modeled on top of the large heads.

The Lydenburg heads were all found buried in a pit. This suggests that they were deliberately hidden, and so might have been used in religious ceremonies. They may have been used in dramatic performances, either to entertain spectators or to communicate with this people's gods.

19

4 The Development of Towns in Africa, 800–1300 A.D.

One of the biggest changes in Africa during the first millennium A.D. was the growth of towns. Towns developed for a number of reasons. The population of sub-Saharan Africa grew. At the same time the discovery of metalworking meant better tools and this led to better agriculture. People could now grow more food than they needed, so they could exchange the surplus for other goods. Some groups of people did not even need to work as farmers. This led to the rise of specialists in towns, such as blacksmiths or traders, who could exchange their skills or goods for food.

From 1000 A.D. a number of cities and towns began to grow to a large size through trade. Towns such as Jenne, Ife and Timbuktu in West Africa and Great Zimbabwe in southern Africa all developed at this time. Trade was particularly important in the region known as the Sahel, the area of West Africa bordering the Sahara.

Ancient Jenne was one of the most important of the earliest towns in West Africa. It was located on the Niger River, in what is now Mali. It was in an ideal position for irrigation for agriculture. The earliest occupation of ancient Jenne was in about 50 A.D., when it was probably a community of farmers, with small dwellings, and by 800 A.D. the size of the town had increased remarkably. It grew because it was an important place for trade. The people of Jenne were buying and selling products from around the region of West Africa. The major products were salt, slaves and gold. Gold was traded from the forest regions near the coast of West Africa in exchange for salt which was very rare in those regions. The gold was sold to Arabs who took it across the Sahara. It would be used to buy goods in Europe.

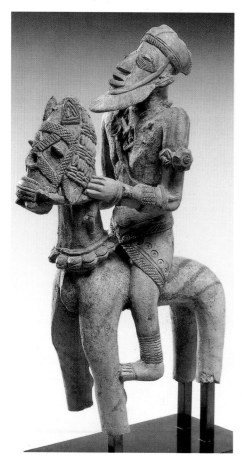

▲ *The Malian terracottas occur over a large region of what is now Mali. The most elaborate come from the ancient city of Jenne and were made between 500 and 800 A.D.*

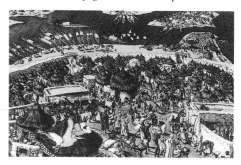

▲ *This painting by Charles Santore shows the city of Jenne about a thousand years ago. It is based on archeological evidence. The city is large and the buildings are made of stone and thatch.*

Art in Ancient Jenne

The terracotta, or fired clay, sculptures of ancient Jenne are its most important art works. They often show kneeling figures, the legs folded under the body to make the base. Often two figures are shown together, embracing each other. There are other horse and rider figures. These are remarkably like later, wooden figures made by the Dogon peoples who live in this area nowadays.

Very little is known about what these figures represent. Perhaps they are images of the founders of the Jenne civilization. Perhaps they are images of Jenne gods or of a myth about the first human beings. ■

20

By 800 A.D. over 10,000 people lived in the town of Jenne. The town was much larger than many European towns of that time. There was a central palace from which the king ruled over the town. Inside the town there were many groups of people, called guilds, each working on its own trade. These groups of specialists had workshops clustered into separate areas of the town. There were guilds of traders and of skilled workers in leather, metal (including gold) and pottery.

Towns also developed in southern Africa. As in West Africa trade and better farming techniques meant that people could live together in large numbers. The most important of these towns developed at Great Zimbabwe. Great Zimbabwe was a town with a population of around 10,000 people. These people had probably lived in the area from about 400 A.D. The first large walls were built about 1100 A.D., and the monumental structures, still standing, were erected around 1250 A.D.

The buildings of Zimbabwe are the largest stone monuments in Africa. Each building was made of granite stones using a technique known as dry-stone masonry. Dry-stone masonry is a way of building with stones that fit together. At the center of the town was a huge cattle *kraal*, a place for holding great numbers of the king's cattle. It is a large stone enclosure and has a diameter of 291 feet/89 meters. The wall is 801 feet/244 meters long, 33 feet/10 meters high and 16 feet/ 5 meters thick. Around the top of the wall is a decorative frieze of stones, and projecting from it are large stones known as monoliths.

A number of stone buildings were built around the cattle *kraal*, and on the hills surrounding the city were houses linked by enclosed pathways. The largest building at Great Zimbabwe was the king's home and, around him, in the royal compound, lived the royal family. The people of Zimbabwe lived in smaller dwellings, made of wood.

The size of Great Zimbabwe suggests that the town was the capital city of an important state. The people living at Zimbabwe were originally pastoralists but, as the state developed, Zimbabwe extended its power, especially through trade. Eventually the people of Great Zimbabwe were trading with the east African coast. Here they were able to buy many goods including Chinese beads and Indian pottery, from Arab traders who brought them down the coast by sea.

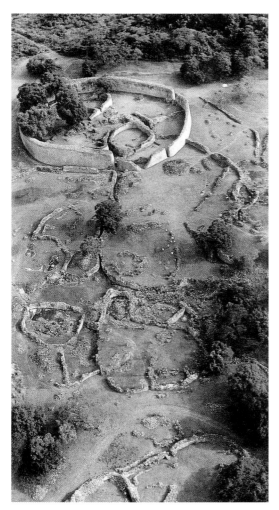

▲ *The ruins of Great Zimbabwe are shown in this photograph, the great enclosure in the foreground. The walls are all built of stone with no cement.*

▼ *This soapstone bird made between 1200 and 1400 A.D., was found at Great Zimbabwe.*

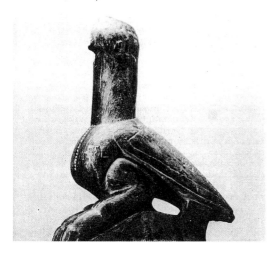

The Stone Birds of Zimbabwe ____

The soapstone sculptures of Zimbabwe are the most famous of all southern African sculpture. Placed on top of the walls of the great city of Zimbabwe, they reminded the people of the great power of the king and his ability to help them in times of crisis. They were also a symbol of the power of the Great Zimbabwe empire. ■

Sculpture in Nigeria, 1000–1500 A.D.

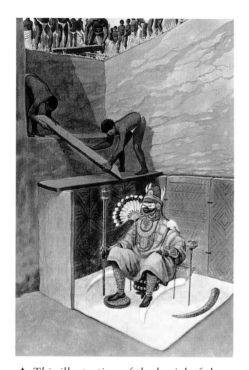

▲ *This illustration of the burial of the priest king of Igbo Ukwu shows that the king was buried sitting on his seat in a wood-lined tomb. All around him are objects of his wealth. This is a reconstruction from archeological evidence.*

The most important early metal sculpture in Africa has been found in Nigeria. Sculptures from two places, called Igbo Ukwu and Ife, show the great ability of early artists. Igbo Ukwu is in the east of Nigeria where the Igbo people now live, and Ife is in the southwest where the Yoruba people live. Both places are in the rain forest belt of Nigeria.

There is no longer a city at Igbo Ukwu. All that remains now is the forest that covers much of this region, but once it was a thriving and wealthy town. In the ninth century A.D. the people of Igbo Ukwu lived in a large city, controlled by a rich king. There were different classes of people: under the king were the merchants, and they had slaves working for them. Igbo Ukwu gained its wealth by controlling much of the trade in southern Nigeria. It was the starting point for trade in many of the forest products, such as ivory, that would eventually be transported over the Sahara Desert to Europe.

We know about Igbo Ukwu only because an African farmer digging his land fell into a royal grave. Now archeologists have made many more discoveries. The most important discovery was of a royal burial. The corpse of a man was found sitting on a stool in a wood-lined room. The corpse was surrounded by objects indicating his wealth. His foot rested upon an elephant tusk and in his hand there was a decorated iron staff.

The most important object found in the Igbo Ukwu burial were cast in bronze. The people used what is called the lost-wax method to make bronze castings and many have been found. They include a

How Were Early Metal Castings Made?

One technique of casting metal is called lost wax, or *cire perdue*. This method gives a very detailed finished object. It is better than any other metal-working technique. It is not surprising that the early metalworkers were also ceramic sculptors because clay is essential in the process. The technique is still used in Africa today.

The production of lost-wax castings is usually surrounded by many ceremonies, often to gods of iron, and it is rare for women to be involved in the process. The technical process begins when a figure is made in clay. This can either be a full sculpture or may only be a simple core. Wax is then set onto the clay model. This wax is then modeled, and fine features of representation can be carved or sculpted into it. Wax rods are sometimes attached to the wax figure, they act as air holes to let the hot air leave the mould. An outer layer of clay is moulded over the wax and the whole piece is placed in a fire. The wax melts and is carefully poured out.

While the wax is being melted out, the smith smelts brass or bronze. This is done in a furnace using charcoal and bellows to create a high temperature. The most delicate part of the whole operation is pouring the molten metal into the cast. This has to be done with care, as the metal must reach into all the areas left by the wax. Care must be taken that no air is left in the mold. Finally the whole figure is left to cool very gradually. ■

number of small heads, with marks on their faces. There are also everyday items such as bowls, which look as if they have been made in pottery, the detail is so fine. Lifelike sculptures of animals, such as flies and frogs have been cast on some of these objects. There are swirling patterns and often floral designs on many of the pieces.

Because the detail in the bronze casting is extremely fine we believe that these objects were made as prestige objects for a king, but we may never know what their significance was. There is one clue, however, which comes from the modern people of the area near Igbo Ukwu. In the nearby town of Nri the Igbo people still bury their chiefs sitting upright in the grave. These chiefs are always priests of the earth goddess. It is possible that a centuries old tradition has survived until the present day, and that maybe the king of Igbo Ukwu was also a priest of the earth goddess. The objects and their symbols may all have been made for worship of the earth.

In the eleventh century A.D. a city developed to the west of Igbo Ukwu. This was the city of Ife. Ife rose because it controlled the trade routes from the forest regions of West Africa. Nowadays Ife is a modern town in western Nigeria. The Yoruba people claim that Ife is where the gods created the world. In the early years of this century archeologists discovered that the traditional stories of the Yoruba had some historical basis.

According to the Yoruba, the world was originally covered in

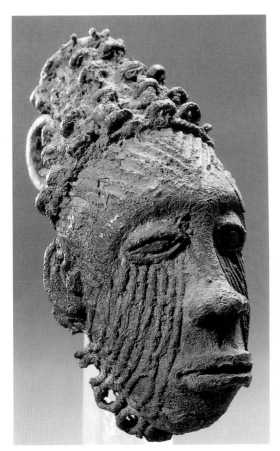

▲ *Bronze pendant heads, such as this one made in the tenth century* A.D., *would have hung down from the belt of a wealthy man at Igbo Ukwu. Heads like this may have been portraits of slaves captured in war.*

This pendant in the form of a double egg ▶ *with beaded chains, found at Igbo Ukwu, was made in the tenth century* A.D. *of bronze, copper and glass. It was probably used as an ornament on a man's belt, showing that he was wealthy. We do not know why the Ife people would make a pendant in the form of two eggs but perhaps, eggs had a religious significance as they do today in Nigeria. On the surface of the eggs are motifs of flies, cast in intricate detail. A bird with large bulbous eyes sits between the two eggs. The significance of the bird is not known, but bird symbols are still used in Nigeria today to show that a man is an important chief or king.*

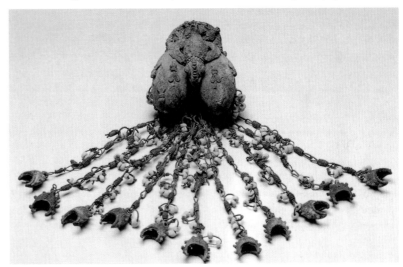

Prestige Objects _____

Many objects found at Igbo Ukwu and Ife were made for use by the king and his family. They are called prestige objects. They show that the king was a powerful and wealthy man who could control artists. ■

water. At Ife, the high god, Olorun, let his son Oduduwa down from heaven on a chain. Oduduwa carried with him a five-toed cockerel, a palm nut and a handful of earth. Oduduwa placed the earth on the water and let the cockerel scratch the earth to make dry land. Then he planted the palm tree, the branches of which represented the ruling families of the Yoruba.

The people who live at Ife have a second myth which may contain more historical fact. This myth suggests that Oduduwa was in fact a prince from an area east of Ife, who invaded and eventually established a royal dynastic rule over all the inhabitants of the area. Many of the royal families still ruling in Yoruba towns claim to be descended from Oduduwa. The most important of the Yoruba kings rules in Ife. This king is known as the Oni and even today is a very important figure not only for the people of Ife, but for all Yoruba.

The palace of the Oni is placed at the center of the town of Ife. It has been the central architectural feature of the town since it was founded in the twelfth century. It has many different compounds and secret shrines devoted to the dead descendants of Oduduwa. The palace also houses many shrines to the gods of the Yoruba people. Around the palace Ife developed as a busy trading town. There were many different quarters in the town. Some were owned for generations by families and are called lineage quarters; others were inhabited by craftsmen or by the slaves of the king.

In 1938, workmen digging the foundations of a house in an area known as Wonmonije, behind the palace in Ife, came across an oval-shaped lump of metal. Closer examination revealed this to be a bronze head of great antiquity. This was proof that the city of Ife was an important early town, lived in by people who were very skilled in making works of art. More and more discoveries have been made there since then. Probably the greatest find of all was made in 1957, when building foundations were being laid in an area of Ife known as Ita Yemoo. In this area a number of sculptures of full figures were found. Other sculptures have been found, but modeled in terracotta, not cast in bronze. There is one figure cast in bronze that has

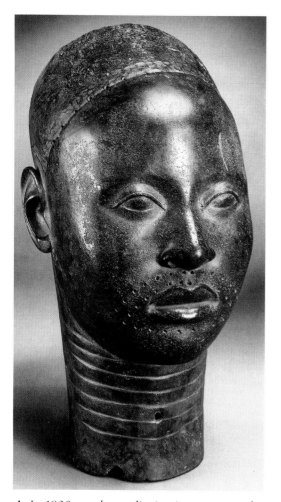

▲ *In 1938, workmen digging in a compound near the palace of the king of Ife discovered this head. It was made between the twelfth and the fourteenth centuries A.D. and is a life-size representation of a dead king of the people of Ife. These heads were probably portraits of kings, and were used for second burials, when a wooden figure of the king, with a naturalistic metal head would have been paraded around the town.*

The Tada Bronzes

Anthropologists made an extraordinary discovery on the banks of the Niger River. In a village called Tada, 300 miles/480 kilometers from Ife, they found a full-size metal sculpture of a man. The villagers believed this was a god and once a year took it to the river to wash it. The metal sculpture was made in the Ife tradition in about 1400 A.D., and shows that the power of Ife extended this far north. ■

This Tada bronze ▶ *figure dates from about 1400 A.D. The casting is so fine that even the rolls of fat on the man's stomach can be seen.*

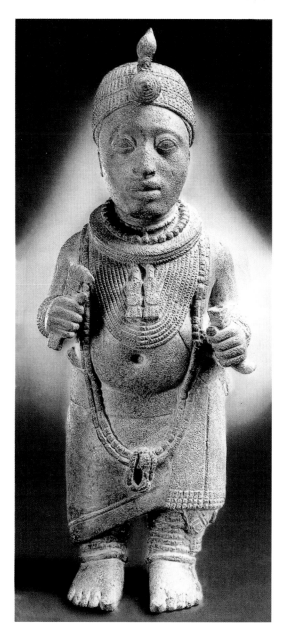

▲ This zinc brass figure shows a king of Ife between the twelfth and the fifteenth centuries A.D. in the costume that he would have worn for his coronation. In his left hand he holds an animal horn that would have been filled with magical substances, and in his right he holds a wooden staff. On his head is a crown that is typical of Yoruba kings' crowns of this period. Around his neck and on his chest are beaded necklaces showing his authority.

never been buried. It is a face mask kept in a secret room in the palace at Ife.

Like those at Igbo Ukwu, the bronzes in Ife were made by the lost-wax method. The heads are very lifelike. Some have crowns on their heads and clearly represent individual kings. Many also have lines incised into their faces. These would have represented lines on the faces of the individual rulers, and this is more evidence that they were portraits.

The heads would have been used for a custom called second burial. In hot climates it is common for the dead to be buried very quickly, without a grand funeral. It is still important, however, that a funeral be performed, often some time after the actual burial, and this is called a second burial. In some areas a full-size model of the deceased person is made and then buried. It may be that each head found in Ife is a portrait of a king which would have been placed upon a full-size figure made in wood. It would have been dressed in the king's regalia and paraded around the town so that people could mourn their dead ruler, but at the same time see that the institution of royalty was still alive.

Terracotta sculptures have also been found in the town showing all the naturalistic traits of the bronze castings. This tradition may have been based upon the terracotta sculpture of the Nok people.

There was no direct link with the Nok—the town of Ife came many years after Nok—but throughout the first millennium A.D. there were contacts between towns, and they influenced one another throughout the West African region. The technology and forms of Ife art are all local, but the brass that was used in the castings came from beyond the Sahara.

Ife Figures

In Ife there are a number of small sculptures made in metal. These depict the king, sometimes with his wife. All the figures found wear royal regalia (the beaded necklace and crown) and carry in their hands a flywhisk and a antelope horn, symbols still used by Yoruba kings today. On the king's head is his crown, with a conical feature above his forehead. Around his neck is the royal necklace, made of coral beads and with two badges of the king's authority hanging on his chest. The faces of these pieces are always shown looking forward and wearing a dignified expression. Perhaps it will never be known for what purpose the figures were made, but they may have been used in ceremonies commemorating the ancestors of the king of Ife. The great skill required to make the pieces clearly places them at the height of the Ife bronze casting tradition. ■

Empires of Ethiopia, 600 B.C.–1900 A.D.

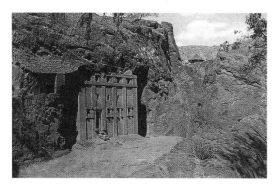

▲ *This is the thirteenth-century A.D. Christian church of Abba Libinos in Ethiopia. It is cut into the rock face of the cliff and would always have been difficult to reach. It is built in a very similar way to the Axum monuments, proof that there was a continuity between the empire of Axum and the later Christianity.*

While cities and empires were developing in West Africa, there were also great changes in the towns of East Africa. One of the most powerful and longest lasting states in all Africa grew up in Ethiopia. It developed in the mountains that form the northern end of the Great Rift Valley of East Africa. The mountains allowed the people of Ethiopia to control trade passing through their land in times of peace, and offered defense when there was trouble. Ethiopian culture developed within the mountains untroubled by outside intrusion or invasion until the twentieth century A.D. This does not mean that Ethiopian culture was unchanging. Its development can be broken down into three periods: the first is 500 B.C. to the first century A.D.; the second, the first century to the fourth century A.D. and the third period is the fourth century A.D. to the present.

The early period is marked by the development of towns. These began as agricultural communities and grew to become centers for the worship of gods. The gods of the early Ethiopians are unknown but we do know that they were associated with the rulers of the towns. Often the temples of the gods were built next to or near royal palaces, which were the largest buildings in many of these towns. At the town of Yeha there are temples and palaces that date to 600 B.C. and fine bronze objects have been found in the ruins. Among the ruins are Arabic inscriptions,

Some of the stone monuments in this view of ▶ *Axum are among the tallest free-standing monuments in the world. The central pillar is 71 feet/21 meters high. They were probably erected to commemorate the rulers of the pre-Christian Axum empire.*

Axum and the Old World

Axum was the center of a great trading network. Many things from all over the old world have been found in the tombs. A necklace of Roman silver coins shows that the town traded with Rome, and there are also the remains of Indian silk textiles and Byzantine lamps. ∎

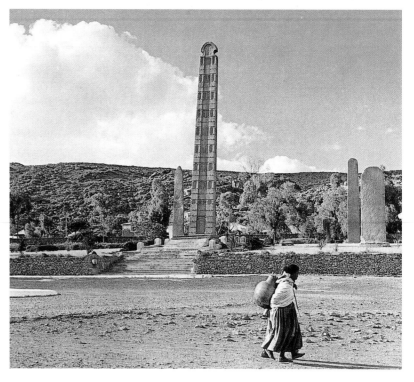

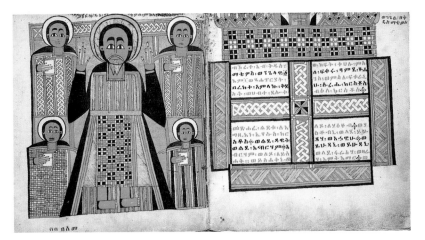

◀ *This photograph shows an illustration from a seventeenth-century A.D. Ethiopian Coptic Bible. The Bible and the stories from the Gospels were known in Ethiopia from the fourth century A.D. but no Coptic Bibles from before the thirteenth century survive. However, because all Ethiopian painting follows rules which have hardly changed over many centuries, we believe illustrations such as this one on wood probably show what the early Bibles were like.*

Christianity in Ethiopia

The new Christian religion became widespread in Ethiopia between the fourth and sixth centuries A.D. It is possible that it reached Axum from the Middle East and it is known that much of the early missionary work was carried out by nine Syrian saints. The Gospels were translated from Greek into the local language, Ge'ez, and they have retained a central importance in Ethiopian Christianity. The result is that there are illustrated copies of the Gospels which rival the medieval bibles of Europe, although none survive from before the thirteenth century A.D. They are written on parchment, made from animal skins, and often contain full portraits of the Apostles and their symbols, just as they are depicted in Europe.

Also important in Ethiopian Christian ceremonies were large processional crosses. In the Ethiopian church the cross was not just a symbol of the resurrected Christ, but also an icon, warding off evil. ■

◀ *This bronze coin is from Axum, the first place in Africa to make coins. The coin dates from the seventh century A.D.*

evidence that the people of these early Ethiopian empires were trading with the Arab nations that had formed along the Arabian Sea.

In the first century A.D. the town of Axum in the Tigray highlands of northern Ethiopia became powerful. The rise of the Axum empire probably resulted from its extensive trade with the Arabian states of the Red Sea and with the Greek and Roman empires of the Mediterranean. This trade probably developed through the port of Adulis on the coast of Tigray. Coins which come from Rome have been found at Axum and Adulis. The society at Axum was divided into several different classes. The town was ruled over by a king, and there were wealthy merchants. Serving the merchants were slaves, who were an obedient source of labor for building the great monuments. The religion of the people of Axum was probably the worship of the moon god, Ilmouqah, who was also worshipped in Arabia.

The architecture of Axum is monumental. The most important individual monuments are stone *stelae*, which are gigantic stone slabs. These stones are carved to represent buildings, complete with doors and windows. On the top of each *stele* are holes which were probably used to attach iron symbols of the sun and the moon and perhaps, after the fourth century A.D., the cross. A total of 119 of these stones have been recorded and they were probably used to mark the tombs of important people. Underneath these stones were found huge tombs, built as palaces, perhaps for kings to use in the afterlife. Other buildings in the town of Axum were equally massive, and were a sign of the great wealth of the town. It is possible that the architecture was influenced by Arab and Indian building styles.

By the fourth century A.D. the people of Axum had converted to Christianity. By the seventeenth century the capital of Christian Ethiopia had moved to Gondar in the Ethiopian highlands. The architecture of the later Ethiopian churches is very similar to that of the early palaces. This shows that there was continuity even when the new religion was introduced.

7 Benin and Asante, 1500–1800 A.D.

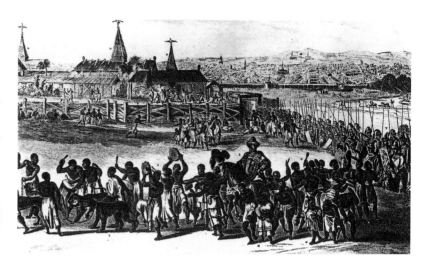

This view of Benin was etched by a Dutch ▶ artist in the seventeenth century A.D. The artist must have been one of the first Europeans to arrive. It shows the king in procession leading two leopards. In the background is the palace and town of Benin.

Benin City Walls

The Benin city walls are made of earth. They are the largest earthworks in the world. They are so big that they can be seen from space. At its height Benin was surrounded by walls enclosing an area of 50 square miles/130 square kilometers, but the total length of the intricate maze of the walls is 10,000 miles/16,000 kilometers. They took many centuries to build. ■

The Oba of Benin in his coral-bead robes and wearing his crown. This is a modern king of Benin but the robes he is wearing are the same as those of his ancestors. ▼

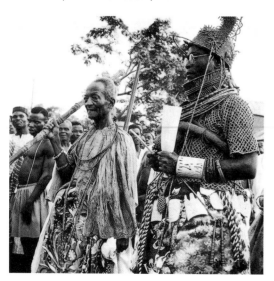

The city of Benin in southern Nigeria was once the center of a large and important empire that stretched along the coast of West Africa. It lies to the west of the Niger River and is nowadays the capital of the Edo people. The population of the city is 160,000. To the west of Benin are the Yoruba and to the east various groups of people known as the Igbo.

Benin was founded in the late thirteenth or early fourteenth century A.D., just when Ife was reaching the height of its power. A number of small villages in southern Nigeria joined together to protect themselves from invasion and to trade with each other. Together they made up the city of Benin.

Legends in the city of Benin say that each one of the village chiefs wanted to be king of the entire town, and could not choose among themselves. The elders of Benin then appealed to the town of Ife. The legend states that Oranmiyan, who was a grandson of Oduduwa, came to Benin from Ife to settle the dispute and became the first king himself. He married a Benin woman but then moved back to Ife, leaving behind his wife and his first son. His son was called Ewuare and he became the king. In honor of Oranmiyan the title of the king in Benin is Oba, just as it is in Ife. All the Obas of Benin have claimed to be descended from Oranmiyan and his son Ewuare.

Benin became more powerful than Ife. The Oba Ewuare was a great warrior and expanded the area that Benin ruled. By the sixteenth century A.D. Benin controlled all of southern Nigeria. The people of Benin conquered many of the surrounding peoples and levied taxes from them for the Oba. This was one reason why Benin became so rich. Another reason was that Benin controlled trade throughout

Bronze heads such as this one of an Oba, ▶ *made in Benin City in the fifteenth or sixteenth century A.D., would have been placed upon an altar devoted to the worship of a dead king. In Benin every family must make an altar to its ancestors, but only the royal family is allowed to have these heads cast in bronze. They had a special guild of artists, known as the Igubemesan, for this work. This head is an example of the early period of Benin heads, as is shown by the thinness of the metal and the fineness of the casting. Later heads are less like portraits and use much more metal in their construction.*

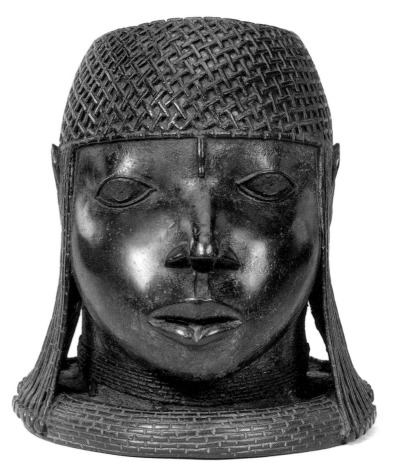

▼ *Heads of the queen mothers, like this seventeenth-century brass one, were almost as important as the heads of the Obas. They always have a conical hairstyle like this which would have been braided with coral beads.*

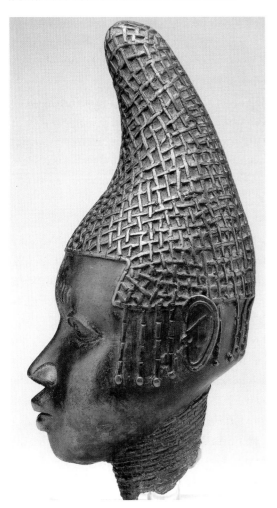

the area. When the Portuguese, who were the first Europeans to reach Benin, arrived in 1472 A.D., they also established trade with the people there. This, too, added to the Oba's fabulous wealth.

The city of Benin was divided into two halves by a broad road that ran through the middle of town. On one side of the road, in the center, was the palace. Here the Oba lived surrounded by his court and his wives. On the other side of the road was the town, which was run by a group of senior men known as the town chiefs. The town chiefs

The Queen Mother

The Queen mother is the most important woman in Benin. She is honored because she gives the people their king and because she was married to the king's father, who was of course a king too. The queen mother is often a very powerful person. Even the king has to obey the decisions she makes in the palace. The cast heads of the queen mothers are made in brass. They are recognizable because they always have a long hairstyle that rises in a peak above the head. ■

This ivory leopard was carved in Benin in ▶ the nineteenth century A.D. Ivory carving in Benin was controlled by the king's guild of carvers and only the king could have objects made for him in ivory. In Benin mythology the leopard is the king of the bush while the Oba is the king of the town. It is appropriate then that the leopard should be the symbol of the king of Benin, because the king rules over both the town and the bush.

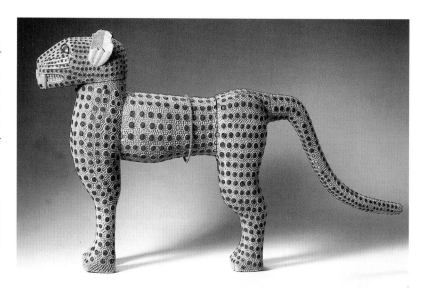

Animals in Benin Art_

Benin artists often included animals in their work. Bronze casters made huge, terrifying pythons which were placed on top of the Benin palace, with their heads looking out towards the town. The ivory carvers of Benin also made sculptures of animals. Leopards and mudfish were often represented. Artists made sculptures for the Oba to show people his power. ■

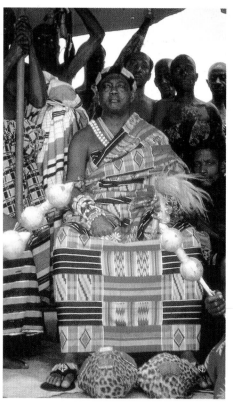

▲ *The Omanhene of Kumawu surrounded by his court. He looks very similar to the way the Asantehene would look.*

were responsible for the day-to-day running of the empire. The Oba was the central figure in Benin and the people revered him like a god. The palace had many courtyards where the palace chiefs lived. They organized the Oba's life, and the Oba's wives.

The king was also surrounded by guilds of craftsmen who worked only for him. The metal casters' guild was one of the most important. Benin is famous for its cast brass objects, made only for the king to show how important and powerful he was. The knowledge of how to cast in brass was brought to the town from Ife by the Oba Ewuare's grandson, the Oba Oguola. The most important brass objects were heads, but other ornamental objects were made for the Oba to decorate himself with for important occasions. The guild of metal casters also made brass plaques with which the king decorated his palace. These plaques showed scenes from palace life, and were important historical records.

Brass was not the only material used to make art. The guild of ivory carvers lived in the palace. Whenever a hunter captured an elephant, he had to offer one tusk to the Oba. The Oba gave these tusks to his ivory carvers. They would carve them in many different ways. Some of the tusks would be carved with scenes from the reign of the Oba. These make a history in ivory, spiraling up the tusk. Other tusks would be carved into intricate items of royal regalia, or symbols such as fly whisks.

The most famous of these ivory carvings are the hip masks. The Oba would wear them on ceremonial occasions, for instance when he went to the shrines of the various gods in the town, or when he had to make sacrifices to protect the town from evil. During these special occasions he would wear a huge, hooped skirt and a tunic, both made from red coral beads. At his waist he would wear the ivory masks.

The other great empire of the West African coast was that of the

▲ *The golden stool was said to have come down from heaven in 1701 A.D. when the Asante confederation was established after the Akan defeated the Denkyira. The myth is that the Asante were about to lose one of their biggest battles when the counselor to the king, a man called Okomofo Anokye, called up to heaven for the help of their god. The god then sent down the golden stool saying that as long as the Asantehene sat on it the Asante would never be defeated. In 1867 the British tried to take the stool and there was an uprising against them. It was the symbol of kingship for the Asante.*

Asante standard goldweights, like these made in the nineteenth century by the lost-wax process, were used to calculate the right price for gold. They were made of brass and all weighed the same, though they do not all look the same. ▼

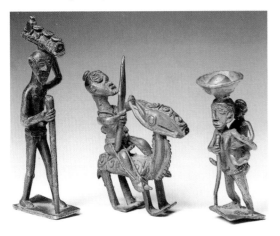

Asante. The Asante empire grew out of a number of smaller states in what is present day Ghana. These were created in the fifteenth century A.D. by peoples known as the Akan. By the sixteenth century the larger Akan states had decided to unite. The reasons for this are not absolutely clear, but the evidence suggests that it was to help increase their agricultural productivity and to engage in trade on the coast, a trade which was primarily based upon the exchange of gold. At first this confederation was opposed by the Akan's immediate neighbors, but the Akan imposed their rule over large parts of southern Ghana in a series of wars. These ended in the defeat of a neighboring people, the Denkyira, in 1701.

The town of Kumasi was at the center of the Asante empire. The leaders of the confederation elected a king to rule over them. The title of the king was the Asantehene. The first Asantehene was Osei Tutu, who became a great warrior and conquered many lands in the north of Ghana. The symbol of his kingship was a golden stool.

Stools are important symbols of the family among the Asante. The head of a family sits upon a wooden stool. It was appropriate that a stool made from gold should symbolize the soul of the Asante nation, as the Asantehene was the father to all the Asante. In order to reinforce the unity of the nation the king made the leaders of the regions give small personal symbols to be attached to the golden stool. The golden stool symbolized more than the king's power, it was a symbol for the entire Asante nation, that they should always remain together.

Asante art is used to support the central position of the Asantehene in the people's life. There are many symbols of kingship among the Asante. Art is so important to them that whenever an artist invents a new design, the Asantehene has to see it and confirm that it can be used. Images are used not only to identify the king, but also to show what titles the chiefs had. This type of "political" art was found in the form of golden umbrella tops, staffs carried by messengers, gold chains and state swords. It carries a message to the people who see it.

Divine Kingship

Many states have a ruler who is seen as a god. In Benin special rites are carried out at the king's coronation which make him like a god. The king's body is thought to be a container for the power of the gods. Myths surround the origin of some kings. In many places the king's ancestor was originally a stranger. Perhaps this is why the king in some societies is represented as a man on horseback. Societies with a divine king often have elaborate artistic traditions. Art shows the power of the king and is produced only for the king. ■

8 Africa and the World, 1300–1700 A.D.

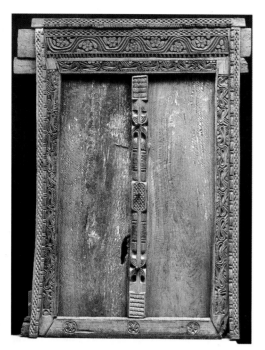

▲ *Contact with other peoples left its mark on African culture. This nineteenth-century Swahili wooden door shows the architectural style which developed from Islamic and African styles. The decorative, geometric patterns of the door reflect those found in the Koran.*

The Sankore mosque at Timbuktu is the ▶ *earliest mosque and one of the finest examples found throughout the Sahel.*

Ships of the Desert

The Sahara Desert has often been compared to a sea. The name of the region immediately to the south of the Sahara is the Sahel, which means shore. The towns of the Sahel, such as Timbuktu and Jenne are like ports. Because camels are the only animals which can cross this "sea", they are often called ships of the desert. ■

The people of Africa, Europe and the Middle East have always been in contact. This contact led to many changes, new ideas and innovations in African societies. Much of the earliest contact with Africa was through trade. Many products came from Africa, including spices and ivory, but gold was the African product in most demand. Much of the gold used in the old world before the discovery of America was from West Africa.

The first and most important traders in Africa, carrying gold, spices and slaves, were Arabs. They often bought goods there and sold them to Europeans. Arab traders worked in two parts of Africa. In East Africa they traded on the coast, but to reach West Africa they had to cross the Sahara Desert. The desert was not easy to cross and made trade difficult. One animal, the camel, could cross it. Traders would stop and load or unload their camels at the towns of the Sahel, such as Jenne and Timbuktu.

The Arab traders brought their religion to Africa. The Berber peoples of North Africa converted to Islam about 600 A.D. and, as they were the main traders in the Sahara, they spread their faith. By the thirteenth century a number of Islamic states, ruled over by Africans, had developed in the Sahara. One of the largest was Mali, controlled

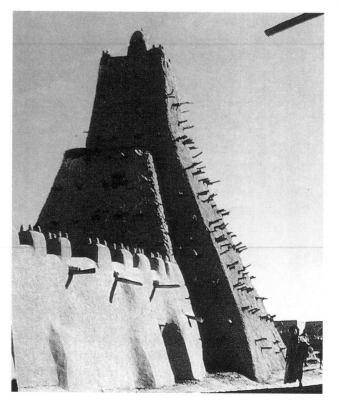

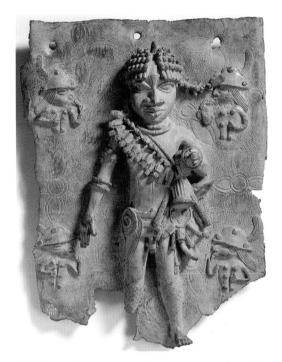

▲ *From the seventeenth century* A.D. *the palace walls of the Oba of Benin were covered in brass plaques like this one. The style of headdress helps to identify the four small heads as Portuguese.*

This Sherbo- ▶ *Portuguese saltcellar was made of ivory in the sixteenth century* A.D. *In this instance, the saltcellar is a gourd-like bowl resting upon a stand made up of Portuguese figures. The executioner on the top of the bowl was probably a great chief.*

by the warrior king Mansa Musa, who reigned from 1312 to 1337 A.D., and whose capital was at Timbuktu. Much of the architecture of the Sahel region is Islamic in style, and in many towns the most important building is the mosque.

On the east coast of Africa, Arabs from the Middle East had traded with the local people from about 300 B.C. Because they needed to talk to each other the Arabs and the local people developed a new language called Swahili from Arabic and the local language. Some of the Arabs settled on the coast at towns such as Mombasa and the island of Zanzibar. They developed a new architectural style which combined Islamic and African styles.

By the fifteenth century A.D. another group of traders appeared in Africa: the Europeans. Before the fifteenth century very few Europeans had actually reached south of the Sahara. Instead they relied upon Arabs for their trade. They could not sail down the coast, because the currents and the winds in the Atlantic Ocean made it hard for sailors to return home. Changes in European sailing ships in the fifteenth century allowed Europeans, especially the Portuguese, to sail to West Africa, and get back home easily for the first time.

By 1472 the Portuguese had reached the city of Benin and began to trade there. The relationship between the Portuguese and the royal palace in Benin was so good that throughout the sixteenth century A.D. Portuguese soldiers even fought on the side of the Benin army in wars with its neighbors. Portuguese soldiers are commemorated in Benin in sculptures and on Benin plaques.

The quest for new goods, especially spices, led the Portuguese from Benin to the Kongo and then eventually to Vasco da Gama's (approx. 1469–1525) journey in 1497 around the Cape of Good Hope to India. The new coastal trade had a great effect upon Africa, turning the overland trade toward the coast. Coastal empires expanded while those in the interior diminished. The greatest effect of Portuguese sailing technology, however, changed the world forever—Christopher Columbus's (1451–1506) discovery of the Americas in 1492.

Sherbo Ivories

The Portuguese acted as patrons to local African artists. One of the things they commissioned were saltcellars, the high point of this artistic collaboration. These are bowls made to contain salt. A bowl with a lid stands upon a tapering stem, thin at the top with a broad base. Often figures are carved around the base of the stem. These come from the West African coast at Sierra Leone and were made by the master carvers of the Sherbo people. ■

9 Empires of the Forests

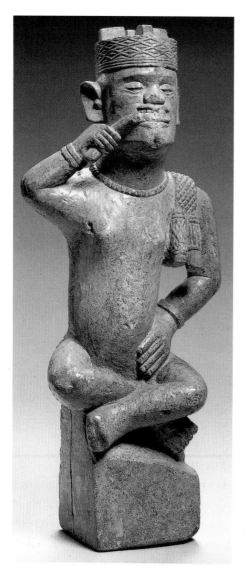

▲ *This Kongo* mintindi *stone figure was made in the nineteenth century. These figures date from the sixteenth century* A.D. *onward, and their gestures and postures suggest that they may be symbols of important kings.*

The forest of Central Africa, in what is now Zaire and Zambia, was the birthplace of the Kongo empire. The Kongo empire was established in the thirteenth century A.D. The capital was at Mbanza Kongo, now called São Salvador, and the king was named the Mani Kongo. The armies of the Mani Kongo had a reputation for being very fierce and the Kongo empire quickly established itself in control of all the people along the Congo River which is now known as the Zaire River.

The Portuguese first reached the Kongo empire in 1484, when they sailed up the estuary of the Zaire River. There was a period of great cooperation between the Portuguese and the Kongo. The king of the Kongo people even became a Catholic in 1506, taking the Christian name of Alfonso I. He reigned from 1506 to 1543 A.D. The Portuguese particularly wanted ivory at that time and they gave the Mani Kongo iron bars called *manillas* in exchange. However, by 1660 war had broken out between the Portuguese and the Kongo, after quarrels about trade. The Portuguese by this time had started to trade in slaves which angered the Mani Kongo, as they were taking his people. The Portuguese destroyed Mbanza Kongo, forcing the Mani and his court to retreat into the forest. By the beginning of the eighteenth century the great Kongo state had collapsed. The people whom the Kongo empire had conquered, became independent and formed their own empires. Some of these, like the Kuba and the Luba empires, became very powerful.

The earliest works of Kongo art are carvings used to show the graves of important men. They were stone carvings called *mintindi*. The figure would be made during the life of a king or important chief and would be kept by him until he died. Then it would be placed on his grave, to remind people of his power. Generally these figures would be carved sitting crosslegged, often holding symbols which reminded people of their characters while they were alive. These sculptures were not portraits of the dead. They were meant to represent the personality and achievements of the person concerned.

After the collapse of the Kongo empire, two related states developed in the south of the region, now known as Angola and southern Zaire. These were the Kuba and the Luba states. The most powerful of these states was the Luba, which eventually spread as far east as the borders of modern day Tanzania.

The Luba increased their empire by warfare, but also through alliances with other groups of people. Often they would secure the

Fetish Figures

A word commonly used by some art historians to describe all African sculpture is the fetish. A fetish is an object that has magical powers. It can be called upon by its owner to protect him or to hunt his enemies. The people of the Kongo made fetish figures. They are called *minkisi*. To make a fetish a sculptor carves a wooden figure onto which medicines of various types are placed by a ritual expert known as a *nganga*. Generally these medicines are placed within a box that is tied onto the middle of the sculpture. Sometimes the box is covered with a mirror and sometimes a cowrie shell is placed in the middle of the box. Whenever the *nganga* wants to call the power of the *minkisi* he hammers a nail into the wooden figures. Often the entire body of such a figure is covered in nails or pieces of iron. It has been suggested that the people of the Kongo state first had the idea of adding nails after seeing Christian pictures of Christ on the cross. ∎

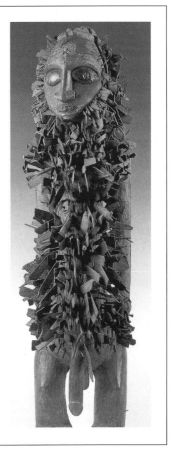

Figures like this one, known as minkisi, *and made of wood, cord and iron in the* ▶ *nineteenth century* A.D., *are among the most powerful carvings in Central Africa. Figures of special importance are known as* minkisi nkondi, *a name that means hunter. They are so named because, with the addition of magical substances they hunt down wrongdoers. These sculptures are sometimes carved in the form of an animal such as a dog.*

◀ *Bow stands such as this wooden one from Zaire made by the Luba were indicators of status. Only important chiefs were allowed to carry these objects. The carving is often an historical character from Luba history. In this case it is a woman who led her people to rich Luba hunting grounds. It was probably made in the nineteenth century.*

alliance by giving works of art to neighboring kings. These works of art would make the chief more powerful in the eyes of his people.

One of the most important symbols of chieftaincy was the bow stand. Bow stands were functional objects, used for holding a hunting bow and arrows. Royal bow stands were carved and are not used in hunting. The carvings are often of women and they are said to be the queen mothers of the Luba people who helped them form their empire.

The other great people of the rain forest were the Kuba. The Kuba live beside the Kasai River, one of the tributaries of the Zaire River. The name Kuba covers a number of different groups of people but they all recognize one king, who is called the Nyim. The Nyim always came from a Kuba people known as the Bushoong because the Bushoong were the people who founded the Kuba empire and the first king of the Kuba was a Bushoong. The name of the first king of the Kuba was Shayaam aMbul a Ngoong. He created the kingdom of the Kuba around 1600 A.D.

Much of the art of Kuba culture honors and celebrates the king. At the election of a Kuba king a sculpture is made for him. These are royal figures called *ndop*. Each *ndop* figure represents the characteristics of the king and it is possible that these figures are portraits. Each king can be recognized by his personal emblem. The king is carved

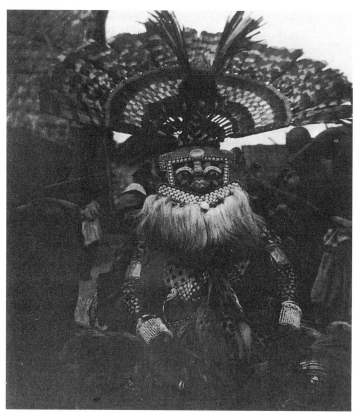

African Historians

It is often possible to know the early history of some African societies even if there are no written records. This is because these societies have historians. Among the Kuba their historians are called *tembo*. *Tembo* do not write anything down but learn by heart all the important things about the society. They can then be called upon by the king if he wants to know something about his ancestors. This is called oral history. ■

◀ *The Kuba king, Kot aPe, is dressed in his regalia as Woot, the first man.*

sitting crosslegged on a pedestal, and his emblem is in front of him. There are several of these emblems, such as a game board, a drum or a cockerel. Each figure wears a peaked hat known as the *shioody*, worn only by the king, and cowries are carved on his arms and his belly.

This wooden statue ▶ represents Shamba Balongongo, the king who introduced the boardgame of wari to the Kuba people. It was made in the seventeenth century A.D.

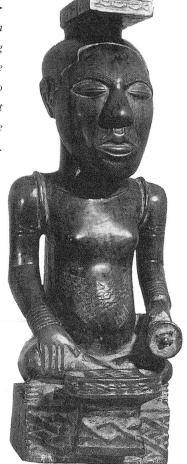

Divination

Divination is a way in which certain people are able to tell the future or find things out by using magical powers. Among the Kuba there are men who use special tools to communicate with the gods who tell them the future. The diviner uses a disk to rub sculptures with smooth backs while he repeats his requests for information. Whatever the diviner is saying at the moment a disk sticks to the sculpture, is the answer of the gods. ■

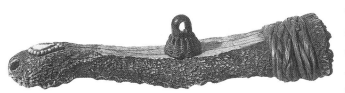

◀ *This object, a crocodile jaw, is used by the Kuba people in their divination rituals.*

Emil Torday and the Kuba

The first white person to reach the Kuba was Emil Torday (1875–1931), a Hungarian anthropologist and museum collector. He trekked up the Kasai River and was introduced to the Kuba king, whose name was Kot aPe. Torday was well received by the Kuba because he gave the king a live crested eagle, a bird admired and thought by the Kuba to be powerful. In exchange Torday received many Kuba works of art. ■

◀ *This is how a Kuba village would have looked in Emil Torday's time. The houses are made of grass and thatch. Surrounding the village is the rain forest.*

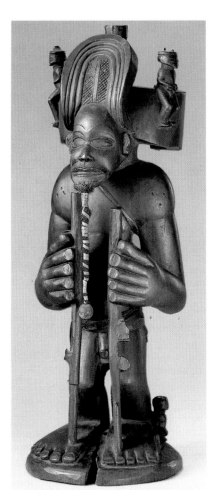

▲ *This figure of Chibinda Illunga is of wood, and was made by the Chokwe people about 1800 A.D. Chibinda Illunga was usually shown with his hunting equipment, a reminder that this man was a great hunter and warrior as well as a civilizing hero.*

The origins of Kuba leadership can be traced back to Shayaam aMbul but the Kuba say that the first man was called Woot. Woot was like Adam in the Old Testament, because they believe he was made by their god. The next human beings were born to Woot and his sister, who was also his wife. Each year the king of the Kuba performs a festival at which he dresses up as Woot. This is to remind the people of the Kuba that he is not only their king, but that he is also the direct descendant of Woot, the first man.

The effects of the Luba and Kuba empires were felt throughout Central Africa. The Chokwe, for example, had a simple life, living in small village communities. In the eighteenth century the Luba took many of them into their empire. The Luba did not rule over them, but taught them about kingship and royalty. The Chokwe people sent gifts and goods to the Luba and the civilizing influence is commemorated in their sculpture.

Chibinda Illunga

Some African art has stories or myths attached, such as the sculptures of Chibinda Illunga. Chibinda was a great hunter and prince among the Luba people. One day, while hunting he spied a beautiful woman, Lweji, princess of the Luanda people. Chibinda Illunga and the princess fell in love. Chibinda taught the Luanda many things. One day, after their marriage, Lweji gave the Luanda symbols of power to Chibinda. This displeased her brothers, but they could do nothing but move away. They settled with the Chokwe people of Angola, intermarried and taught them the things that Chibinda had taught them. They became powerful chiefs. The Chokwe still carve the figure of a Luba prince to commemorate the foundations of their royal family. ■

10 The Yoruba

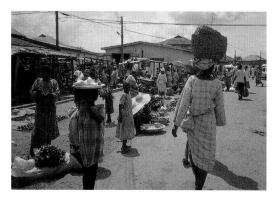

▲ *These are Yoruba women going to the marketplace. This is one of the main areas of trade for women. They are carrying yams on their heads.*

▲ *This example of Afro-Brazilian architecture, the Lagos central mosque, has very elaborate designs and decoration derived from the architecture seen by slaves in Brazil. They carried these ideas back to Nigeria after their release from slavery in Brazil in the late nineteenth century.*

There are now over 15 million people who call themselves Yoruba. The main area of the Yoruba is still southwestern Nigeria, just as it was when Ife was at its height in the fourteenth century A.D. The Yoruba are an urban people, the majority of them live in towns. Each of the towns has a similar layout. Almost all Yoruba towns have a king, known as the Oba. The king's palace is always at the center of the town. Facing the palace is the marketplace. In most towns the market is held every four days, but there is usually a small daily one as well. The market is controlled by women and women are the main traders in southern Nigeria. Men have a number of jobs. Some are specialists working in the town, such as blacksmiths or car mechanics, but most are farmers. They work on the farms which are cut out of the rain forest that surrounds the town.

Many of the Yoruba people today are Christian or Muslim, however the myths and legends of the Yoruba gods are still important in people's lives today. Many Yoruba still maintain the worship of the gods that would have been familiar to the people of early Ife. In most Yoruba towns there is at least one festival during the year to celebrate the gods associated with the town.

The Yoruba have many gods. Olorun created the world at Ife, and is the high god of the Yoruba, but he is never shown in a work of art, and people do not worship him. Olorun is said to affect the world through other gods called the Orisha. There are many different Orisha and some are more popular than others.

The Orisha that are found across the whole of southwestern Nigeria are called Ifa, Eshu, Shango and Ogun. The god, Ifa, who is sometimes known as Oranmila, is the voice of the gods. Through divination, which is explained in chapter nine, he can tell humans

Afro-Brazilian Architecture

In many Yoruba towns the architecture is a mix of the old styles and a style known as Afro-Brazilian. Older Yoruba houses are single storied and have little decoration. Afro-Brazilian buildings are very ornate. They are usually two stories high and have a great deal of decorative detail. They are derived from a Portuguese-Brazilian style. Slaves brought it back with them when they returned to Nigeria in the late nineteenth century after the abolition of slavery in Brazil. ■

◀ *The figure of Shango, the Yoruba god of thunder, is always recognizable by the representation of two ax-like tools about the figure's head. These are said to be his thunderbolts. This double-headed version was carved in wood in about 1930 by Obembe of Efon Alaye.*

How Yoruba Came to be Written Down

There was very little writing in sub-Saharan Africa before the nineteenth century. Yoruba was one of the first languages to be written down. Samuel Crowther (1809–1891), who was one of the first black missionaries in Africa, wanted to translate the Bible into Yoruba. First he worked out how to write Yoruba down and then he could translate the Bible. ■

▲ *This is a Yoruba diviner at work. The Ifa tray,* opon ifa, *is covered in fine dust into which the diviner makes the marks given to him by Oranmila, the god of divination.*

what the gods want from them. Eshu, Ifa's close friend, is the trickster god, often upsetting human plans. Shango is the god of thunder and is sometimes accompanied by Yemoja, goddess of the waters. Ogun is the god of iron. Oduduwa, maker of the earth, and Orisan'la, maker of human beings, are especially important at Ife.

Many of the wood carvings made by Yoruba carvers are used in the worship of the Orisha. Not all Orisha are carved: Ifa, for instance, is not given a human form. The objects needed to find out his messages to people are the most important in Yoruba religious worship. Ifa makes his messages known by commanding a diviner, who is a priest trained in Ifa worship, to make marks on a special board, known as an *opon Ifa*. Often around the edge of the board are carved scenes from everyday Yoruba life. Each board always shows the face of Ifa's friend, Eshu.

Eshu carries the praises and sacrifices of human beings to the gods, but he is a difficult god, often playing tricks upon people. Eshu is often carved as a man with a long headdress projecting from the back of his head. Sometimes he is shown wearing a cap. One half of the cap is blue and the other half red, to confuse people. Cowrie beads are used as money in the marketplace so very often strings of them are tied to the sculptures, signifying Eshu's role in market trading. Market trading is

This Ifa divination board is one of the ▶ *earliest pieces of Yoruba wood carving to remain intact. It was made in about 1600 and is for Ifa divination. Marks are made in the central circular part of the board and from these marks a priest is able to tell the future. The head at the top of the board is of Eshu.*

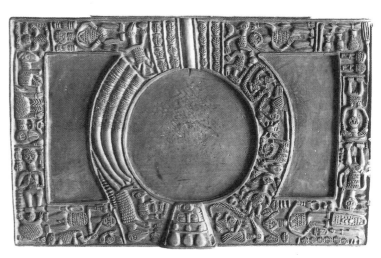

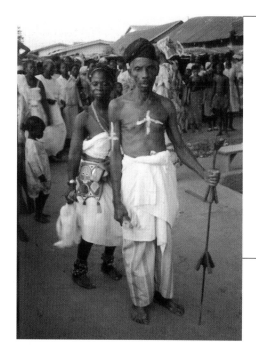

Babalawo

Yoruba diviners are known as babalawo. This means father of secrets, and these men have much knowledge about the gods, especially Ifa. A babalawo's training is very long, and he has to remember by heart all the chants that Ifa gave to mankind. Each babalawo has his own religious tools, which he can carry around with him. Many people still consult babalawos if they feel that there is something wrong with their lives. ■

◀ *This babalawo in the Yoruba town of Ife is wearing ritual dress and carrying ritual items.*

often associated with the characteristics of deceit and cunning.

Shango, the god of thunder, is another Orisha sometimes carved as a human being. In myth Shango was the fourth king of Oyo, a large and ancient Yoruba town. He became too powerful, was thrown out by his people and committed suicide. However, he was so powerful that he was taken up to heaven and made into a god. Carvings are used in dances by the priests and priestesses of Shango. These dance wands are always identifiable because of the oval shaped headdress on the carving. They are often shown with red and white beads which are the colors of Shango.

There are many different Yoruba carvings, not only of the gods. A Yoruba carver often shows scenes from the life he sees all around him, especially on doors and houseposts. Carvings might show women going to the marketplace, men riding horses or bicycles and even, nowadays, young couples at a disco.

Yoruba carvers had to go through an extensive training, becoming apprentices to an acknowledged master. It was a long training of over five years and the apprentice would first learn how to use a knife to carve the fine details on the sculpture, and then finally how to use an adz, which is an ax-like tool, to make the basic shape, the most important part of the work.

If a carver was good at his trade then he would be honored and remembered. In the past good carvers were always in demand. Art objects were made not only for religious reasons but would also be commissioned by kings and rich men. Some of the finest pieces of Yoruba carving were made to celebrate the wealth and position of chiefs and kings. These works would often be part of the architecture of palaces or wealthy compounds. Doors would be carved with scenes of importance in a king's life, and posts holding up roofs would be carved as figures, such as horsemen, to show wealth, or as women, to show the fertility of the house.

Ibeji Figures

The most common woodcarvings in a Yoruba town are *ibeji* figures. These are small doll-size figures owned by women. They are used to replace a dead twin. *Ibeji* means twin. Twins are said by the Yoruba to be children from heaven. If one or both of them die they have to be praised and fed as though they were still living. A small carving is made for this purpose. Many are made so they are a good way to learn about carving styles. ■

These Ibeji ▶ *figures are statues of twins. They are treated like living children and give blessings to the house.*

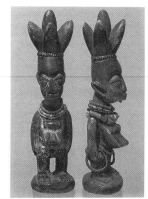

A Yoruba Carver

One of the best Yoruba carvers was Olowe of Ise (approx. 1890–1939). His work is clearly important because it is found in the palaces of kings, a considerable distance from his home.

Olowe was born in the small Ekiti Yoruba town of Efon Alaye sometime in the latter part of the nineteenth century. When still young he moved with his mother to the town of Ise.

His work is very distinctive. The figures are elongated. With a sense of movement in them, the figures seem almost to break away from the confinement of the wood they are carved in. Olowe's best known works are palace veranda posts, used to hold up the roofs of palace courtyards, and doors. One such door was sent to the British Empire Exhibition in 1924. Olowe's palace posts are carved as kings and warriors often supported by women. ■

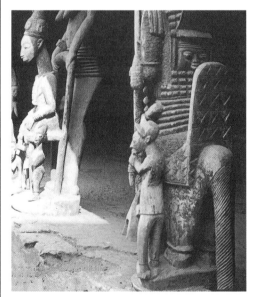

▲ *These veranda posts were carved in wood by Olowe of Ise in the early twentieth century. They are shown at the king's palace at Ikerre. They show the carver's elongated style. The figures of kings and warriors are supported by those of women.*

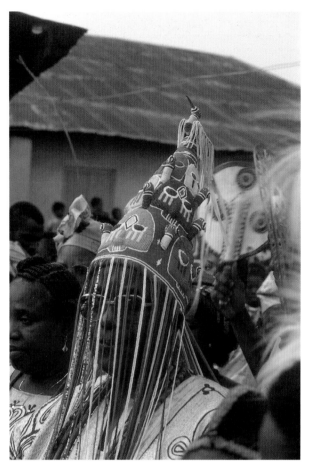

▲ *This beaded crown was worn by the Elekole of Ikole in Nigeria in 1990 during a public ceremony.*

The Yoruba use other materials as well as wood to make important objects. Although they do not make heads of kings as they did at Ife, bronze castings are made. They are particularly important for a group of chiefs known as the Ogboni. The Ogboni are a society of extremely powerful town elders. Most Yoruba towns have an Ogboni society. If a king is a bad ruler then the Ogboni society can depose him. Special objects, known as *edan*, are associated with the Ogboni. They represent a male and a female figure linked to each other by a chain. When the Ogboni society is meeting they drive the *edan* figures into the earth, perhaps because Ogboni is associated with the worship of the earth.

The royal regalia of the king, the Oba, is another area of artistic production. Each year the Yoruba king has to greet his town. It is important, however, that the face of the king is never seen. This is because the king is like a god, and ordinary human beings must never look at the faces of the gods. To prevent people from seeing his face, the king wears a beaded crown. This is a conical hat richly embroidered with glass beads. Falling from the base of the crown is a fringe of beads covering the face of the king. A small bird is sculpted in beads sitting on top of the crown, this is Okun, king of the birds.

Art and Ancestors

This Dogon wooden plank figure is still recognizable as a human figure, although it is very simplified. It is probably over seventy-five years old. The arms are pointing up toward heaven asking for rain. The worn surface of the wood has resulted from people throwing millet porridge at it in offering.

One purpose of art made in Africa is to celebrate and honor ancestors. Ancestors are usually important people, who are said to have died and gone to heaven, but who can still communicate with living humans. Some Africans believe that the world, in which human beings live, and heaven, where the gods and ancestors live, are close to one another. Their closeness means that people remember the ancestors and their relationship to them. For many people in Africa the organization of their society was based upon the ancestors and the lineages, or family groups, to which they belong.

Art is sometimes used to honor people who have recently died, or to honor unnamed ancestors. Art is also used to help promote the leadership of the elders, and to bring all the members of a lineage together.

The Dogon people of Mali have a complex system of lineage and ancestral beliefs. They live in family villages along the Bandiagara Cliffs in Mali. The duties of the village are handled by the eldest men in each lineage. Each family has a compound of small, round houses and granaries. Attached to the compound are shrines to ancestors.

To show respect for their dead mothers and fathers, the Dogon make shrines. The *ginna bana*, one of the elder heads of the village, takes care of the shrine. Twice a year the whole village gathers for a festival, the *bago di*, to honor the ancestors.

A sculpture is made for each of the shrines. The spirit of the dead person enters this sculpture. Offerings are presented and if offered in the correct way, the ancestor is said to be able to help the lineage.

The sculptures are not individual portraits, but simply plank-like pieces of wood shaped to resemble the human body. Sometimes they have a head and a body carved into the middle with raised arms and

Lineages

A lineage is made up of a group of people related to one another and claiming descent from a common ancestor. In societies based on lineage, people need to know their place in the society and also where they have come from. The line of descent can be traced either through the mother's family (matrilineal descent) or from the father's side (patrilineal descent). Very often whole villages can trace their descent from just one or two ancestors and everybody in the village is related. ■

Ancestral Bones in Gabon

In some places the actual bones of the ancestors are kept by the people. Carvings are made to protect these bones. The Fang people in Gabon follow this custom. The bones of the dead are kept in woven baskets and a sculpture is placed on the tops of these baskets to warn away anybody who comes near. The carvings are not portraits of the dead but are said to contain the soul of the dead person. Because of this, offerings are made to the sculptures. ■

Heads such as this nineteenth-century Fang reliquary head from Gabon are among the rarest ▶
pieces of African art. It is shiny because of the oil poured on it as an offering for peace.

▲ *This statue of Ala, the mother and earth goddess of the Igbo people, is the central figure of an* mbari *house.*

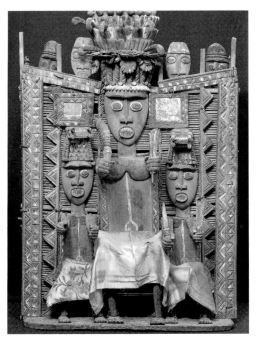

▲ *The ancestor and head of a trading family is the central figure of this Kalabari screen.*

hands pointing to heaven. This kind of carving is a form of praise to the ancestors asking them to look after the living people of their lineage, and especially that they send rain from heaven.

The largest group of African people to use lineage as a means of social organization are the Igbo of eastern Nigeria. Each Igbo village has a number of elder men who look after the running and politics of the village. Sometimes an entire village joins together to make a form of art called the *mbari* house. An *mbari* house is a specially built house with a number of different sculptures in it. It is made of mud and, although a senior artist watches over the building progress, many villagers take part. An *mbari* house is made to look like an ordinary house, but it is never lived in. The interior of the house is filled with sculptures modeled in clay. The key piece of sculpture is always the goddess, Ala, who is the Igbo earth goddess. Many other sculptures are made with different themes and are meant to show people the proper way to live their lives. Once an *mbari* house has been completed there is a great celebration and the people of the village view the finished work.

In New Calabar, located on the Niger River delta, individual ancestors are honored. The Kalabari became important middle men in the fifteenth century, in the trade of slaves and palm nuts with European traders.

Kalabari trading houses were set up based on lineages. Dead ancestors became closely linked with trade, for they were said to be interested in how well their decendants were doing in business.

The people of New Calabar made ancestral screens from wicker and wood to ask ancestors for help. The dead ancestor is shown sitting in the center, sometimes with other figures on either side. Signs of wealth, such as a sailing ship, might be shown with the ancestor. Often the central figure is shown wearing European dress, such as a top hat, characteristic of early European traders. Top hats, decorated with feathers, are still worn by Kalabari traders today.

Secret Societies and the Art of the Mask

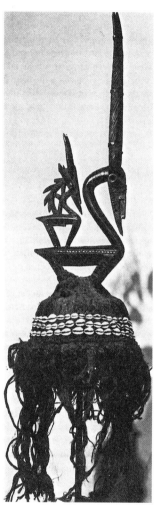

▲ *The dance headdress of this wooden mask, probably made in the 1970s represents the Tyi Wara spirit of the Bamana people.*

The most spectacular art of Africa is the masquerade. A masquerade involves woodcarvings, cloth, painting, dance and music. It involves dressing up in a costume that hides the wearer. It can be used as a great celebration or it can be a very dangerous thing. Masquerades are performed in many places throughout Africa.

The most important element of any masquerade is the mask. A mask is placed over a dancer's head so that people do not know who is dancing. This means that the person inside the mask can represent a spirit or an ancestor, and people will not know that it is a man. Very often people say that there is no man in the mask, that it really is the god who has come to visit them. It is often believed that the person wearing the mask has been changed from an everyday man into a god or a spirit.

Not all masquerades have the same effect and masquerades can be used for different purposes. Sometimes the mask just acts as a device to make a performance more dramatic. At other times the masquerade mask hides a real change in the person who is doing the masquerade. The person may feel he becomes the spirit of the masquerade and may not even be conscious of what he is doing. In many masquerade performances spirits are said to come and take over the performer's body. At yet other times a spirit may be said to live in the mask itself, so that when it is worn the whole society can see their god.

Masquerading has so many different effects, it is not surprising to find that masks are used in many different ways. Some are used purely for entertainment whereas others are very secret and only used in religious ceremonies. In some lineage-based societies young men use the disguise of wearing a mask to make criticisms of their elders or to comment on local village life. In other societies the masquerade makes people think very deeply about their place in the world and their relationship with the gods. In almost every place that masquerades are used, however, there is a belief that spirits from another world come

The Tyi Wara Masks of Mali

The Bamana mask of the Tyi Wara masquerade is a male antelope with large head and horns that arch over a body. Perched on top of the male antelope is a female. Her horns follow the curve of the male antelope. The Tyi Wara celebrate the first agriculturists, who the Bamana people say were antelopes. ■

In the dance of the Tyi Wara, one male and one female antelope dance ▶
together digging their front feet into the ground.

Witchcraft

Masquerades are often said to be about stopping witches from working. In Africa it is common to find people who believe in the power of witches. Witches can be men or women, but they are usually women. The worst thing that a witch can do is take away children and masquerades are said to stop this from happening. ■

and these spirits visit the everyday human world.

Masquerades are often said to represent the dead, either as individual named ancestors or as ancestral spirits that come from heaven. Masquerades are commonly associated with funeral rituals, either at burials or at remembrance ceremonies. During a funeral the person who has died is said to pass to the world of the dead. It is the masquer-

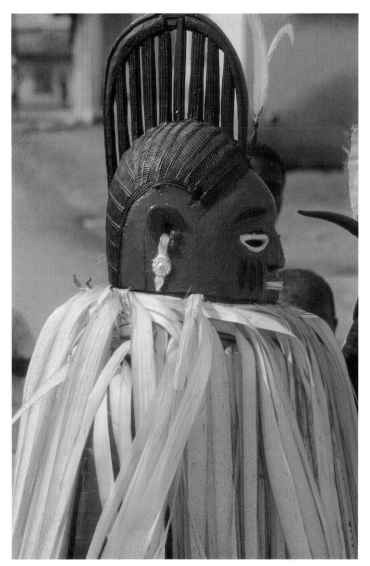

▲ This is an egungun mask of the Yoruba, recently made in wood. It is shaped like a beautiful woman, but its purpose is to frighten witches.

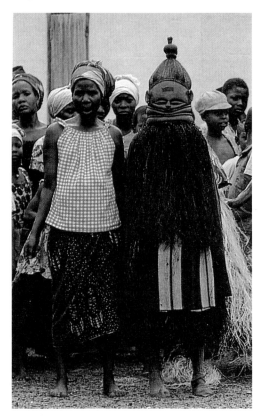

▲ This is a wooden Sande mask of the Mende people. The picture, which was taken in the 1970s, shows a woman's Sande mask accompanied by her attendant who calls out her name to announce her arrival.

Women and Masquerade

In Africa women are excluded from wearing masks and from knowing what happens in the masquerade. Myths about masquerade are said to start with women owning masks that are then stolen by men. There is one society whose members are exclusively women and which use masquerades. The Sande society that is found in Sierra Leone and Liberia initiates girls into being women and teaches them the secrets of womanhood. At the end of the initiation period various rituals are performed and the initiates are said to have become adults. ■

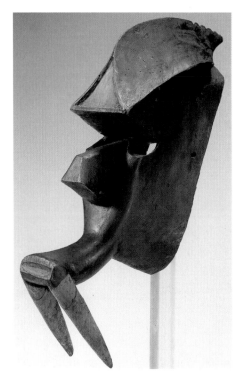

▲ Gon *masks, such as this one, were made of wood by the Kwele people in the nineteenth century to frighten their neighbors. It is designed in the form of a gorilla with huge teeth.*

Masks of War

A masquerade mask can be used in warfare. Sometimes the leader of a band of warriors would wear a mask to scare the enemy. One group of people who used masks in warfare were the Kwele people of the Congo. Their masks were called *gon* and were carved to imitate a gorilla. They had very large teeth and a great crest. It was used to strike fear into the surrounding peoples. ■

ade that carries him there.

Masquerades are also used in other rituals which transform a person from one role in life to another with a more senior status. The masquerade is used in initiation ceremonies. During these ceremonies, which generally take place away from normal town life, boys are exposed to masquerades, often first to scare them and then to teach the young men about life. This introduces another element of masquerades, for often they are associated with the forest. The masks are thought to be spirits from heaven or the world of the ancestors that emerge from the forest.

Because wearing a mask is a disguise, masquerades are very useful for the members of secret societies. A secret society is an association of men who group together to act as a type of police force. In the past these were very important to the running of many African communities. There is often an element of initiation in these societies, which may involve the use of masks. Masquerades may be used in these societies in several ways: to reinforce the control that these societies have over those who are not initiated into the secret of the society, to make

▲ *Dogon masquerade masks, such as these, in performance at the base of the Bandiagara Cliffs in Mali, are rarly seen.*

Animal Masquerades

Animal masquerades are found throughout Africa. The types of animal represented vary from society to society, as does the way of representing them. Animals stand for the forest and the wild. The types of animals fall into two categories: those used by men and those feared by men. In the former group are animals such as the buffalo and antelope and in the latter, leopards and gorillas. Animal representations may derive from myths, where the animal was involved in the creation of mankind. Among the Dogon, masquerades of animals are performed to celebrate those animals that helped the earliest ancestors of the Dogon. Animals are things that live in the bush and outside human knowledge so in some ways they are powerful things. The Dogon masked ritual is very complex and the senior mask only appears every sixty years, but among some of the most powerful masquerades are those representing animals such as the monkey, the antelope and the leopard. ■

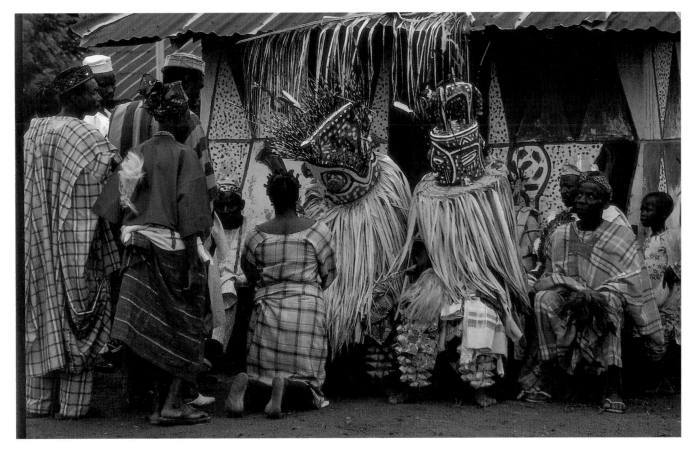

▲ *These wooden* epa-*type masks, made in the 1970s, are used in a Yoruba performance. They are being saluted by the women of the town.*

Yoruba Masquerades

The Yoruba also make and perform masquerades. There are three different types of Yoruba masquerade. In the southern region they perform a masquerade known as *gelede*, in which men dress up as women to honor women. A mask, known as *epa*, is used in another type of masquerade. These are the largest masks in Africa made from a single piece of wood. They often have carvings of figures standing above a pot-shaped mask with bulging eyes that is worn over the head. The third type of masked performance is known as *egungun*, and is performed throughout the Yoruba region. Its purpose is to honor the dead. ■

and carry out judgments, to find and expel witches and, occasionally, to provide a disguise in warfare, which in West Africa was often carried out by junior society members. Often the forms of masks and the kinds of symbols displayed are related to the differing types of use.

Within one group of masquerades there can be a number of different styles, each of which may have a different effect. Yet despite differences in carving styles and differences in use there are common features in a broad range of subject matter found in African masquerades. The way African masks represent their subjects varies very widely. However, a number of themes seem to recur in masquerade although the purposes of use vary from society to society. Some of the most common themes in masquerade are the representation of ancestors; animals which might bring agricultural fertility to the community; people from outside the society, who are often represented in a satirical or rude manner; and very often women, although these masks will be worn by men.

The one thing that all masks share is that they are human representations of an unknown spirit world. This means that, within the limits of the technology available, the kinds of masquerades and the rules governing them can be extremely wide ranging. What is perhaps more of a surprise is that the masquerades of different societies have so much in common.

13 Body Art

In some African societies the human body is turned into a work of art. The human body can be changed in many different ways. Some are permanent transformations, such as scarification and tattoo. Other changes are short term, such as body painting or hairstyling.

Scarification is a process in which small scars are made on the skin of the person. Generally this is done by making cuts in the skin with a blade. The cuts are made to heal into scars, either by reopening the wounds at intervals or by rubbing something such as ash into the skin. The cuts heal leaving marks on the skin.

▲ *This Yoruba barber's shop signboard shows the number of different hairstyles on offer to the barber's clients, in this case men.*

Hairstyles

Hairstyles often have great meaning in Africa. The messengers of a Yoruba king shave one half of their heads so people know they are representing the king. Many African women braid their hair into designs and some of these have names which, among the Yoruba, take their origins from actual events in Nigeria. When Nigerians stopped driving on the left side of the road, a design which pushed the hair to the right was named "Nigeria drive right." ■

▲ *This is a nineteenth-century print of a young Kuba girl with scarification marks on her belly. These marks show that she was a high-ranking woman.*

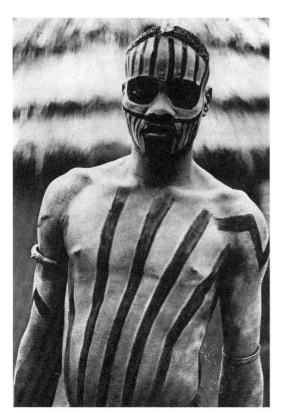

▲ *The Nuba are famous for their elaborate patterning, shown in this photograph. Painting is a celebration of the healthy, adult body. These designs mark the transition to adulthood among males and females.*

▲ *These earplugs, made in the twentieth century, come from South Africa and are used by the Zulu people. They are made from brightly colored pieces of vinyl, plastic and wood.*

The pattern of these scars is often very carefully worked out before any mark is made. Generally the marks follow the contours of the part of the body the person concerned wants noticed. Thus Tiv women of central Nigeria have scarification marks around their calves as this part of the body is thought to be attractive.

Scarification marks also have other purposes. Many of the wood-carvings illustrated in this book show figures with scarification marks. For example, the Kuba *ndop*, the Ife bronze head of a king, has marks on his body. These show that the king is different to ordinary human beings who do not have the same marks on their bodies. Sometimes the marks on a person show that he or she has gone through some form of transformation, such as initiation.

In certain societies a person's position in society is shown in a less permanent way than scarification. Body painting can be an important way of showing to other people that you have reached a certain status in life. The Nuba of southern Sudan use body painting in this way.

Like many other East African peoples, the Nuba are cattle herders. The focus of their social life is the village. Age is important to the Nuba. There are no chiefs and village life is controlled by elder men. Women have scarification marks given to them once they reach child-bearing age. After their first child they stop decorating themselves. Men use body paint to show their age.

To a Nuba man painting is a celebration of a healthy body, it is an indicator of a man's rank in life and it is also, more recently, a way of making money from tourists. Nuba men have three colors with which they decorate themselves: yellow, red and black. Certain colors may only be used once a man has reached a particular age. From the age of ten to eighteen a boy can use red pigment as his basic color, from eighteen to twenty, red and yellow. When he is thought to have reached full manhood, he may use black as well. These are the most basic rules of Nuba body painting, but, within these rules the variation of pattern and design seems to be limitless. Among the Nuba, design and pattern celebrate the healthy young body. Many seem completely abstract, yet others are recognizable as giraffes or leopards. Even if the designs can be recognized, the Nuba claim that they have no meaning other than the colors used to decorate themselves.

Earplugs

Among the Zulu of South Africa the wearing of earplugs is still a source of pride. A young child will have its ears pierced at an early age. Small pieces of corn stalk are placed in the hole which is gradually enlarged. Eventually an earplug can be inserted into the pierced ear. These are often more than two inches/fifty-five millimeters in diameter. Early plugs are undecorated but with the availability of plastic, bright designs have been added. ■

14 Textiles

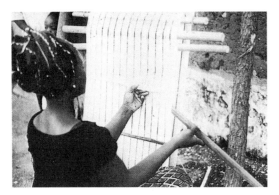

▲ *This Ebira woman in Nigeria is using a broad, single-needle loom to make cloth.*

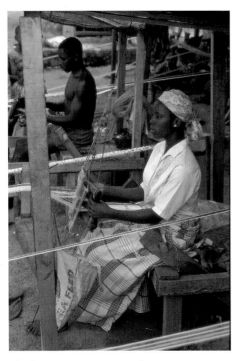

▲ *A young woman works at a narrow strip loom, usually operated by men.*

Textiles are an important part of the culture of many African societies. They are used in rituals, to wrap the dead and as commodities for sale. They are also important works of art.

A textile is a cloth usually made of two threads, generally woven together. Weaving can be done very simply by holding the threads and manipulating them with the fingers. It is much easier if one set of threads can be stretched out on a loom. All looms stretch one set of threads (called the warp) over a frame. The thread is then woven with a second set of threads called the weft. The loom works by levering one set of threads up and down so the other can easily pass between them.

There are many varieties of loom in Africa, but they can be grouped into two basic types, the broad loom and the narrow strip loom. A broad loom creates tension by passing the warp between two poles, the narrow strip loom attaches one end of the warp to a weight and the other to a permanent structure. As their names imply, the two different types of loom lead to different types of cloth, one a wider but shorter piece of cloth, the other a long narrow strip.

Wool and cotton are generally used for the production of textiles in Africa. Wool is used by the Berber Arabs of North Africa, who also use hair from goats and camels. The Berber way of life depends on their sheep, which they follow around the mountains. Cloth has great economic value and is one of the gifts that women bring to their marriages. It also provides material for their tented homes. South of the Sahara, cotton is the type of thread most often used for weaving.

Raw cotton and wool have to be combed and then spun to make a continuous thread. Raw silk and raffia, which comes from the soft insides of the leaves of the raffia palm, are also used to make cloth.

A number of dyes are used to color thread and cloth. Indigo is made from a special vine. Its leaves are pounded and dried and mixed with ash in water to produce a greenish color. Once dry the indigo turns a deep, rich blue. In Mali a type of mud is used to give a black

Asante Cloth and Status

In Asante communities the highest powers in society control what can be worn. Asante cloth is known as *kente* cloth. It is made from cotton or silk. The Asante use the narrow strip loom. Their highly patterned cloth is made from strips stitched together. Some patterns have their own names, such as *adwinasa*, which means "my skill is exhausted", because no more pattern can be put in the cloth. *Asasia* cloth is made only by the king's weavers. The king decides who wears this type of cloth. ∎

color to specially prepared cloth. Hibiscus leaves make reds, as do henna and camwood. Manufactured materials are now being substituted for traditional threads and dyes. This has given the African weaver a much greater range and variety.

The alternation of different warp and weft threads is used by weavers to create a pattern in the cloth. In some cases, such as the Asante *kente* cloth, this can be very elaborate. Embroidery is used to decorate cloth after it has been completed. With needle and thread patterns are worked on prepared cloth. In West Africa embroidery designs are associated with Islamic people. Other groups have copied and borrowed designs from Islam.

Beadwork

Beads are worn like cloth, among the Ndebele people. Beadwork is an important aspect of their art. Beads are attached to skirts, skin and tunics. When a woman marries she wears a beaded train known as an *nyoka*. ■

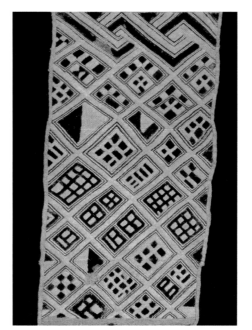

This silk cloth is a type of kente *known as* adwinasa, *meaning "fullness of ornament." The weaver can add no more to the design.* ▼

▲ *This is a fine example of the* raffia *cloth of the Kuba.*

▲ *These are the indigo dye pits in Kano in northern Nigeria. Cloth is placed in the pit to be dyed blue. Men control this trade.*

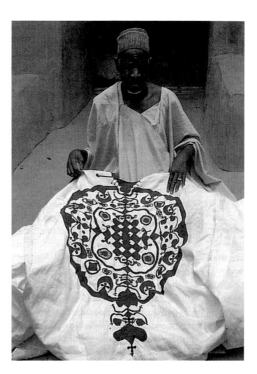

◄ *This man is embroidering a gown for use by an important Hausa man from Nigeria. The thread he is using is a different color from the woven cloth so that the design will stand out.*

15 Arts of Southern Africa, 1700–1900 A.D.

▲ *This view of the Victoria Falls was painted in 1863 in oil on canvas by Thomas Baines. The romantic side of Baines's work can clearly be seen in this work. Faced with the awesome power of the Victoria Falls, his landscape celebrates nature.*

David Livingstone

The greatest explorer of Africa was David Livingstone (1813–1873). A Scottish missionary who believed in bringing Christianity to Africa, he started his career in 1841 in Botswana. He crossed the Kalahari Desert, explored Lake Malawi and was the first white man to see the Victoria Falls, which he named. When he was feared lost, the *New York Herald* sent the explorer, Henry Morton Stanley, to find him. Stanley succeeded and greeted him with the famous words, "Doctor Livingstone, I presume." Livingstone led the struggle to abolish the slave trade in Africa. ■

The first Europeans to arrive at the Cape of Good Hope, the southernmost tip of Africa, were Portuguese. By 1652 the Dutch East India Company set up a refreshment station for its ships traveling to the East Indies and, in 1657, a permanent colony was established. Throughout the next century the Dutch pushed into the interior of the Cape. In 1795, the British, who dominated Africa, annexed the colony and it expanded .

The first known painting of the Cape of Good Hope was a view of Table Mountain painted by Cornelius Houtman in 1598. The first reliable interpretation of the mountain came from the Dutch artist, Walter Schouten, in 1658. Later views of Table Mountain were more impressive in style. Reinier Nooms (1623–88) painted his ship, the *Africa*, in Table Bay and William Hodges (1744–97), a traveling companion of Captain James Cook (1728–79), painted Table Bay in 1772.

The emergence of painting as a professional discipline in South Africa followed the British occupation of the Cape Colony and, after 1800, the number of artists working in South Africa increased. William Bowler (1812–69) arrived in 1833, and quickly established a reputation as a watercolorist and art teacher in the Cape Colony. More adventurous was Thomas Baines (1820–1875) who was a professional explorer and the first artist to paint the Victoria Falls.

The concern of early white artists in South Africa with landscape was in part a result of the explorations of the interior of South Africa that continued throughout the nineteenth century. Dutch settlers,

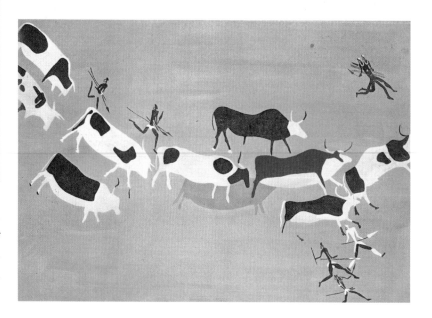

This painting copied from the walls of a ▶ cave at Palingkloof, in the Cradock district of South Africa, shows the San people stealing cattle from white settlers who wanted to move onto their land.

Scramble for Africa ___

In 1884 the foreign occupation of Africa was limited to the coastline. In the south the Boers and British expanded toward the diamond mines. Ethiopia retained its status as an independent state and throughout Africa indigenous rulers still held sway over large tracts of land and people. Freed slaves laid claim to Liberia and Sierra Leone and there was a growing French colony in Senegal. Little African territory was under European rule. All this changed dramatically at the turn of the century. The Berlin Conference of 1884–85 was devised to divide African territory among the European powers. By 1914, Africa was effectively under the imperial rule of these powers. The division of Africa was guided by the balance of power in Europe. Bloody wars and the conquest of vast areas of Africa were undertaken to prevent neighboring European powers from gaining territory. By 1938 the redrawn map of Africa looked like it does today. ■

◀ *Nelson Mandela was very important in changing the South African system of apartheid.*

Apartheid _____

This was a system of segregation developed by the white South Africans in 1948. It meant that white and black people should never be together. It was designed to keep black South Africans out of power, and denied them human rights. ■

▲ *Bernard M. Tshatsinde (1958-) painted this acrylic work on board in 1981 to protest the killings of black people by the apartheid regime. Its subject is the protest marches that took place in the 1980s.*

known as Boers, trekked away from the Cape and set up farms on the plains of South Africa. They established their own colony known as the Orange Free State. In 1860 it amalgamated with another Boer colony, the Transvaal, to form the Republic of South Africa. When diamonds were discovered in the Transvaal, the British, led by Cecil Rhodes (1853–1902), claimed the land as a colony. This led to the Boer War (1899–1902) between the Boers and the British. By 1910, South Africa was declared a country with the name, The Union of South Africa. In 1948 a mainly Boer party called the Nationalists came to power and declared a system of apartheid. It was not until 1994, with the election of President Nelson Mandela (1918–), that apartheid finally was abolished.

Black African artists suffered under apartheid. Much of their work was concerned with the conditions under which black South Africans were forced to live. The first professional black artists were trained at the Polly Street Art Centre set up in Johannesburg in 1948. Much of their work was concerned with showing life in the townships, particularly that of Soweto, the area of Johannesburg where black South Africans were forced to live. In the 1970s challenges to the apartheid system led to brutal white domination. The murder of the journalist, Steve Biko (1946–77) leader of the Black Consciousness Movement, made many artists protest openly about the political conditions in South Africa. They used their work to show the conditions of confinement and torture that many people in South Africa had to endure simply because of the color of their skin.

16 Arts of the African Diaspora

▲ *Young African men, women and children were captured by slave-raiding parties and carried away from their homes. At the ports, they were crammed into slave ships, often not seaworthy, as seen in this print. Throughout the voyage, sometimes called the middle passage, the slaves would be chained together, given very little food or fresh air. Many would never see daylight until they reached the final destination if they did survive the voyage. On arrival they would be auctioned off to the highest bidder.*

The arrival of Christopher Columbus in America in 1492 had great consequences for the Atlantic coast people of Africa. By the end of the fifteenth century the Portuguese had established themselves in the Americas. They had developed a the plantation system in Brazil to supply the demand for sugar in Europe. Labor came from the local Indian inhabitants, but old world diseases, brought by the Europeans, quickly killed many of them. The Portuguese turned to Africa as a source of labor, already adapted to the tropical conditions of Brazil.

Slavery had long been a part of African state systems. The earliest Arab traders bought slaves from African kings for trade across the Sahara. The arrival of Europeans on the continent, however, changed the conditions of slavery dramatically.

By the end of the sixteenth century all major European countries had developed plantation systems in the islands of the Caribbean. All were involved in the trade of taking slaves across the Atlantic. By the eighteenth century the plantation system had spread to the southern United States, where it was used in the production of cotton, and again the demand for slave labor reached a peak.

More than ten million people were taken from Africa. The Portuguese were the main traders taking people from the area between Ghana and Nigeria. However, it was easier to take slaves to Brazil from the Kongo region because the sea passage was shorter. The British, French and Dutch had colonies in the Caribbean and North America, so they took slaves from the West African region, in order to have the shortest voyage. After the abolition of the slave trade in Europe, Brazilian traders still took slaves from the African coast.

Many of the slaves taken to Brazil, Cuba and Haiti were from the Yoruba region, known by the Portuguese as Nago. In these countries

Arts of Maroon Communities

Throughout the Caribbean, Brazil and the southern United States, slaves made objects influenced by their African heritage. Sometimes slaves escaped and set up communities away from the plantations, known as "maroon communities."

Despite terrible persecution from the Dutch, the maroon communities of Surinam, a former Dutch colony in northeast South America, produced an artistic style very similar to African styles. Spoons and calabashes, bowls, drums, canoes and textiles were all produced. ■

People in ▶ maroon communities have made spoons like these for three centuries from scraps of metal. The designs are similar to patterns found on African utensils.

▲ Going to Church *was painted by William Johnson in 1940. This work uses art school materials (oil on burlap) and is painted in the simple style of African-American folk artists.*

This carnival costume was designed by the Trinidadian artist, Peter Minshall, in 1987. Made of strips of cloth, paper and steel, a masked skull holds a huge skeleton that can be moved around using poles. ▼

the Yoruba worship of their gods, the Orisha, described in chapter ten, was thrown into contact with the Catholic church of the slave owners. The Catholic church could not tolerate the open worship of the Orisha, but the slaves learned to adapt the Catholic saints to the Orisha. The Virgin Mary is associated with the deity Yemoja, goddess of the waters, the thunder god Shango (called Xango in Cuba) is associated with Saint Barbara and the god of iron, Ogun, is regarded as Saint James or Saint George. Other Orisha were given attributes loosely connected to the Catholic Church. Eshu, the trickster, is known as Baron Samidi in Haiti, and he is said to rule the world in the time between the Crucifixion on Good Friday and Easter Day. He is often shown as a skeleton dressed in a black suit, or simply as a skull.

Twentieth century Caribbean artists work within this mix of cultures. Carnival is one area where African and European traditions have mixed highly successfully. Carnival contains elements of African masquerade and also European Catholic festivals. Other artists, such as Rigaud Benoit (1911–87) have taken the European tradition of illustrating the saints and put them into their paintings.

In the United States people of African descent have worked as artists since the eighteenth century, generally in the tradition of naïve portrait painting. It was not until the end of the nineteenth century however, that Americans of African descent were offered formal art school training. There was and still is a tradition of untrained artists working in America. Artists such as William Edmonson work in a Visionary style that owes little to formal training.

The first artists to recognize and celebrate black history and culture systematically were the artists of the Harlem Renaissance. A group of artists, assembled around Harlem in New York in the early years of the twentieth century, affected the course of black art in the United States and beyond. The artists of the Harlem Renaissance were also at

Carnival

Masquerade is one of the art forms carried across the Atlantic Ocean by slaves from Africa. The tradition from Europe of staging a carnival to celebrate the beginning and end of Lent, the forty day period of Christian abstinence before Easter, combined with the African masquerade, led to the Carnival in many of the places where people of African descent came to live, such as the Caribbean Islands and Brazil. During Carnival people parade in costumes which are often related to the way people see their past. Spectacular carnival costumes and masks are made which have evolved from West African masquerades. ■

Migrations from the South

After the American Civil War and in the early years of the twentieth century there was a great migration of African-Americans from the southern states to the large towns of the north, especially New York and Chicago. Over four million people left the south. Many of them wanted to get away from the southern states which were still associated with slavery and racism, and they wanted to take advantage of the economic boom in the north. ■

This painting by Romare Beardon (1912-1988), called Pepper Jelly Lady, *is a color lithograph on paper. Beardon made this in 1980 after he had traveled to the Carribean. Pepper Jelly is a sauce used by people in the Carribean and the U.S. The train in the background refers to the migrations of people from the Carribean to the United States.* ▼

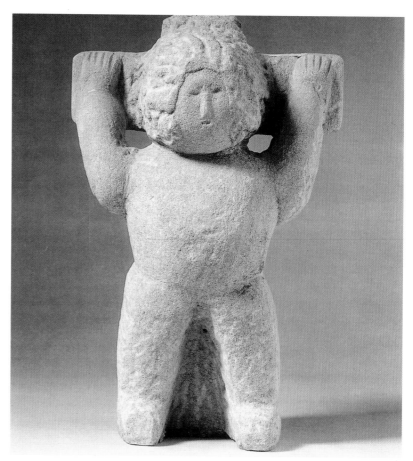

▲ *This sculpture is by William Edmonson (approx. 1882-1951). Edmonson was one of a group of African-American artists known as Visionaries. The group often used religious subject matter in their work. This sculpture is called* Crucifixion *and was made in limestone between 1932 and 1937.*

the forefront of changes in black American attitudes toward their treatment by white America.

Although slavery had been abolished in America after the Civil War conditions for many black Americans in the south were still dreadful. By the 1920s a "New Negro" movement was stimulated by two

W.E.B. DuBois

The driving force behind the philosophy of the Harlem Renaissance was W.E.B. DuBois (1868–1963). He was educated at Harvard. In 1905 he established the Niagara movement which argued for better working conditions for African-Americans. In 1909 it became the National Association for the Advancement of Colored People. He was a part of the movement that campaigned for a return to Africa where great civilizations had been developed by black people. In 1961 he settled in Ghana where he died. ■

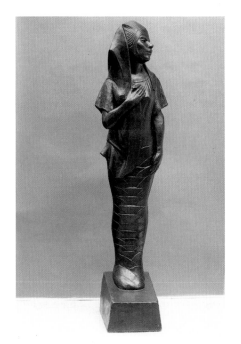

▲ *This sculpture,* Ethiopia Awakening, *was made in bronze by Meta Warwick Fuller in 1914.*

Jacob Lawrence painted In a Free Government, the Security of Civil Rights Must Be the Same as That for Religious Rights. It Consists in the One Case in the Multiplicity of Interests and in the Other, in the Multiplicity of Sects *in watercolor in 1976.* ▼

events: World War I and the migration of many blacks from the south to northern cities. The migrations saw the rise of political activism and the founding of a positive culture for all blacks. Academics such as Alain Locke (1886–1954) and W.E.B. DuBois (1868–1963) encouraged people to take pride in their heritage. One way of doing this was to turn to the achievements of Africa and particularly Egypt.

DuBois's encouragement provided the inspiration for the work of Meta Warwick Fuller (1877–1968), one of the first Harlem artists. In 1914 she produced *Ethiopia Awakening*, a work of Expressionist power in bronze showing the head and shoulders of a young woman, wearing an Egyptian crown, breaking free from a mummified sleep.

Aaron Douglas (1889–1979) was perhaps the best known of the Harlem artists. He came to New York in 1924. He was influenced by the works of Pablo Picasso and European Expressionists as well as African sculpture. He developed a simplified style with flat perspective and overlapping monochrome colors. His greatest work was a series of murals for the 135th Street New York Public Library (now the Schoenburg Center) in Harlem. Entitled *Aspects of Negro Life* this series of four panels in oil on canvas, painted in 1934, is a story of the African-American experience. The series begins in Africa, moves to the experience of slavery and life on the plantation, and ends with the optimism of black Americans in the north.

Many other artists gathered in Harlem. Palmer Heydon (1890–1973) painted scenes from black American life and legends and stories of his youth. His greatest work illustrates the story of John Henry, a black American folk hero. Also working in Harlem was William Johnson (1901–1970), who shunned Heydon's realist manner to paint in a deliberately primitive style.

The work of the artists of the Harlem Renaissance was to have a great influence upon the work of black American artists throughout the twentieth century. Young artists, such as Jacob Lawrence (1917–1989) followed, and successfully developed careers.

▲ *The translucent quality of Aaron Douglas's work can be seen in* Aspects of Negro Life: An Idyll of the Deep South, *1934, painted in oil.*

International African Art

▲ *Iba N'Daiye's statement in this 1970 oil on canvas painting called* La Ronde à Qui le Tour (The Round—Whose Turn Is It) *is against colonialism. Although he uses sacrificial rams to make his point, the message is aimed at Europe and America.*

Many African contemporary artists are trained in art schools, work in large cities and exhibit their work internationally. Artists trained in art schools and working in Africa have been a part of African art since the beginning of the twentieth century. Not until the end of the century have they received any recognition of their work. Some of the most important artists of the twentieth century have come from Senegal and Nigeria.

Iba N'Daiye (1928–) attended the Ecole des Beaux Arts in Paris. Although his work, for example, *La Ronde à qui le Tour (The Round—Whose Turn is It)*, 1970, depicting sheep for the slaughter at the Eid festival, draws on Senegalese life, he has a fierce sense of artistic independence. This was probably one reason why he never accepted the ideal of a uniquely African artistic style. Papa Ibra Tall, an art teacher in Senegal, also trained in Paris. His work was concerned with finding an explicit African foundation for art in the international style. Tall's work draws heavily on the traditions of woodcarving and mythology found in the peoples of Senegal and Mali. A younger group of Senegalese artists is critical of the colonial experience. Artists like Fode Camera (1958–) draw explicit parallels between colonialism and the destruction of Senegalese culture.

Colonial Rule

The effect of colonial rule was to change much of Africa. The political boundaries of the nations of the continent were established at Berlin in 1884–85, and many groups of people found themselves thrown together under European administrations. Even from the beginnings of colonial rule in Africa there was a movement against European domination. By the end of World War II and throughout the 1950s there was growing momentum for the removal of colonial rule in Africa. The struggle for independence from colonialism included many artists. The Nigerian sculptor, Ben Enwonwu (1921–) wrote that, "The struggle for political freedom must clothe itself with the colors of culture." ■

▲ *The members of the Oshogbo* mbari *group were encouraged to use a number of different media in their work. Jimoh Burimoh used beads on board in this 1970 work to show Kano city walls. Kano is a Muslim city in northern Nigeria.*

▲ *Twins Seven Seven and the group of artists that formed around the Oshogbo movement draw heavily upon the decorative imagery that the local Yoruba artists use to illustrate their legends and beliefs. This work entitled* The Anti-Bird Ghost *was made in 1967 in ink on paper and wood.*

This oil on canvas painting is by the Zairian artist Trigo Piula. It is called Ta Tele (Your Television). *It shows a crowd of people looking at a fetish sculpture which has been turned into a television.* ▼

Aina Onabolu

Many Africans felt that the colonial powers often represented African art as backward and "tribal". Aina Onabolu (1882–1963) was one of the first artists to challenge this view. Onabolu was determined to show that African artists could work in oil and on canvas as well as any European painter. He trained in London and Paris and then returned to Nigeria. He produced many portraits of prominent Africans in a style that deliberately followed European traditions of portrait painting. Onabolu was also particularly forceful about the need for art schools in Africa. Some of these ideas were promoted in Senegal by the president, Leopold Seneghor, who set up the Ecole des Beaux Arts in Dakar, dedicated to artists promoting a national and African identity. ■

In Nigeria there was less organized patronage of the arts by the state. The British colonial regime had recognized that Aina Onabolu's (1882–1963) arguments about the need for art schools in Nigeria were correct. They appointed an education officer, an Englishman called Kenneth Murray, who oversaw the development of art teaching in Nigeria from 1931 to 1965. Gradually art schools were introduced to university departments, mostly run by English art teachers, whose concentration was upon technique. Students in Zaria, a town in northern Nigeria, rebelled against the style they were being taught, and began to introduce subject matter and techniques from their own backgrounds. Bruce Onobrakpeya (1927–) was one of the leading Zaria rebels and much of his early work draws upon his Uhrobo background.

In the 1960s, Ulli Bieir, an English teacher at the University of Ibadan started art workshops in the Yoruba town of Oshogbo. Known as *mbari*, these workshops provided art teaching for anybody who attended. In these workshops some of Nigeria's best known contemporary artists had their first introduction to art. The Oshogbo school draws much of its inspiration from the mythology of the Yoruba, although it is interpreted in a unique style. Artists such as Twins Seven Seven (1947–) explore the myths that surround them. Jimoh Burimoh draws much of his inspiration from the same source, and yet works with beads. His images are built up from strings of beads threaded together and stuck to the canvas. He draws upon Yoruba techniques of beaded crown making.

The Zairian artist Trigo Piula (1950–) puts together images of *nkisi* fetish figures with the products of western consumerism. His work is a commentary upon Africa, Africans and the attitude of the rest of the world toward Africa.

Bibliography

Brain, Robert. *Art and Society in Africa*. New York and London: Longman, 1980.

Connah, Graham. *African Civilizations*. New York and London: Cambridge University Press, 1987.

Curtin, Philip, et. al. *African History*. New York and London: Longman, 1995.

Fage, J. D. *A History of Africa*. New York and London: Routledge, 1995.

Gillon, Werner. *A Short History of African Art*. New York and London: Penguin, 1986.

Leakey, Richard and Lewin, Roger. *People of the Lake: Man, His Origins, Nature and Future*. New York and London: Collins, 1979.

Perry, Regenia A. *Free Within Ourselves*. San Francisco and Washington, D. C.: Pomegranate Artbooks/Smithsonian Institution, 1992.

Phillips, Ruth B. *Representing Woman: Sande Masquerades of the Mende of Sierra Leone*. Los Angeles: UCLA Fowler Museum of Cultural History, 1995.

Phillips, Tom (ed.). *Africa: The Art of a Continent*. New York and Munich: The Center for African Art, New York/ Prestel, 1995.

Shaw, Thurstan, et. al. *The Archeology of Africa*. New York and London: Routledge, 1993.

Thompson, Carol. *African Art Portfolio*. New York: The New Press/The Museum for African Art, New York, 1993.

Vansina, Jan. *Art History in Africa*. New York and London: Longman, 1984.

Vogel, Susan. *Africa Explores: 20th Century African Art*. New York and Munich: The Center for African Art, New York/ Prestel, 1990.

Willet, Frank. *African Art: An Introduction*. New York and London: Thames and Hudson, 1994.

Younge, Gavin. *Art of the South African Townships*. New York and London: Thames and Hudson, 1988.

Glossary

adz A metal-bladed tool used for carving wood in much of Africa.

African diaspora The spread of people from Africa throughout the world.

ancestor A member of your family who lived a long time ago.

Asantehene The Asante name for their king.

cire-perdue The French name for lost-wax casting.

divination A way of finding out about the future by using special powers.

Ekiti An area of eastern Yoruba in Nigeria.

Eid The Muslim festival of fasting called Ramadan is ended by a festival known as Eid.

fetish An object that has magical powers and is treated like a god.

fresco A type of painting made on wet plaster.

hunting and gathering A way of finding and collecting food without farming.

lineage Members of a family who are descended from a common ancestor.

manillas Iron bars used by the Portuguese for trade with African people.

Oba The Yoruba name for king.

Paleolithic The stone age period.

parchment A type of animal skin that has been prepared as if it were paper.

pastoralism A nomadic way of life based on raising cattle.

pottery firing A technique of baking clay so that it becomes hard and impervious to water.

second burial In Africa many people are buried very quickly. In order to celebrate their funeral properly, another ceremony is held at a later date.

shamanism The ability of a person with special powers to go into a trance and communicate with the spirit world.

smelt To melt a rock that contains metal ore in order to extract the metal.

sub-Saharan Africa All of Africa south of the Sahara Desert.

townships Town areas where black South Africans were forced to live by the apartheid system.

wari A game, similar to backgammon, played in many different parts of Africa.

Photo Credits

The producers of this book have made every effort to contact all holders of copyrighted works. All copyright holders whom we have been unable to reach are invited to write to Cynthia Parzych Publishing, Inc. so that full acknowledgement may be given in subsequent editions.

courtesy Bawit Monastery: 14 bottom

The British Library, London: 15 left, 27 top

The Trustees of the British Museum, London: 14 top, 33 top, 36 top, bottom left and right, 37 top, 43 bottom, 50 top

The Carlo Manzino Collection: 35 left

Central African Archives, Salisbury: 52 left

Photo © James Faris: 49 top

Foundation Dapper Collection: 28 right

Photo © Peter Garlake: 26 left and right

Roger Gorringe: 22

Hampton University Museum: 51 center

Norman Hardy: 48 right

Photo © David Heathcote: 51 bottom

Humbolt Universitat, Berlin: 15 right

Photo © G. I. Jones: 43 center

McGregor Museum, Kimberley: 10

Musée Barbier-Mueller, Geneva: 34

Musée Dapper, Paris (Lester Wunderman Collection): 42

Musée Nationale des Arts d'Afrique et d'Oceanie, Paris: 46 top

Museo Preistorico Etnographico, Rome: 33 bottom, 35 right

The National Commission for Museums and Monuments, Lagos: cover, 17, 18 left, 23 left and right, 24 left, 25

Reproduced by permission of National Georgraphic Society: 28 top

National Museums and Galleries on Merseyside (Liverpool Museum): 29 left

National Museum of American Art, Smithsonian Institution, Washington, D.C.: 55 top (gift of the Harman Foundation), 56 right (gift of Elizabeth Gibbons Housen), 56 left (gift of the Democratic National Committee), 57 bottom left (gift of the Container Corporation of America)

Photo © John Nunley: 55 bottom

Photo © John Pemberton III: 39 center

Photo © John Picton: 38 bottom, 41 left

Private Collection: 11, 12 top and bottom, 13 right, 16 right, 20 left, 21 top and bottom, 24 right, 27 bottom, 28 left, 30 left and right, 31 top and bottom, 40 bottom, 43 top, 44 left and right, 45 left, 46 bottom, 49 bottom, 51 right, 52 right, 53, 54 right, 58 left, 59 top and bottom

Photo © Labelle Prussin: 32 right

Photo © Mike Rolands: 18 right

Photo © William R. Rea: 38 top, 39 top, 40 top, 41 right, 45 right, 47, 50 bottom, 51 left, 58 right

Sainsbury Centre for Visual Arts, University of East Anglia, Norwich: 29 right

Photo © Carlyn Saltman: 16 left

Photo © Mark Schitz: 48 left

Photo © Marjorie Shostak: 13 left

Schomburg Center for Research in Black Culture; Arts and Artifacts Division; The New York Public Library; Astor, Lenox and Tilden Foundations: 57 top (photo © Manu Sasoonian), 57 bottom right

South African Information Service: 53 left

Staatliche Museen zu Berlin, Preussischer Kulturbesitz Museum fur Volkerkunde: 32 left, 37 bottom

University of Cape Town Collection at the South African Museum, Cape Town: 19

Weickmann Collection, Ulmer Museum, Ulm: 39 bottom

Index

Abba Libinos, church of, 26
Adulis, 27
African-Americans, 54-57
 artists, 55-57
 crafts, 54
 folk artists, 55
African diaspora, 54
Afro-Brazilian architecture, 38
Akan, 31
Alfonso I, 34
Amekhamaini, 15
American Civil War, 56-57
ancestors, 28, 42-44, 46
animal masquerades, 44, 46-47
animals in African art, 10-13, 15, 20-23, 25, 27-28, 30-32, 35-37, 41, 44, 46-47, 49
 antelopes, 11-12, 44, 46
 beadwork, 41
 camels, 13, 32
 cattle, 12-13, 21
 elephants, 12, 22, 30
 giraffes, 10, 49
 horses, 12-13, 20, 31
 leopards, 28, 30
 masquerades, 44, 46-47
 paintings of, 10-12
 sculptures of, 15, 30-31, 35
Angola, 34, 37
anthropologists, 24, 37
apartheid, 53
Apollo II cave, 10, 11
Arabs, 20, 26- 7, 32, 33, 50
archeologists, 10, 19, 22
art schools in Africa, 53, 58-59
Asante, 30, 31, 51
 art of, 31
 Asantehene, 30, 31
 cloth, 51
 goldweights, 31
Axum, 25-27

babalawo, 40
Baines, Thomas, 52
Bamana, 44
Bandiagara Cliffs, 42, 46
Banjeli, 16
Bantu, 19
baskets, 43
beadwork, 21, 23, 25, 28-30, 39, 41, 51, 58-59
Beardon, Romare, 56
 Pepper Jelly Lady, 56
Benin, 28-30, 33
 art of, 29-30, 33
 Obas of, 28-30, 33
Benoit, Rigaud, 55
Berbers, 15, 32, 50
Berlin Conference of 1884–85, 53, 58

Bieir, Ulli, 59
Biko, Steve, 53
Black Consciousness Movement, 53
blacksmiths, 17-18, 20, 38
boardgames, 36
 wari, 36
body art, 48-49
body painting, 48-49
Boers, 51-53
Boer War, 53
Botswana, 52
Bovidine rock painting, 12
Bowler, William, 52
bow stands, 35
Brazil, 38, 54-54
Bubaline rock paintings, 12
Burimoh, Jimoh, 58-59
Bushoong, 35

Camelid rock paintings, 13
Camera, Fode, 58
Cameroon, 18-19
Cape Colony, 52
Cape of Good Hope, 33, 52-53
Caribbean Islands, 54-56
 artists of, 55
carnival, 55
carnival costumes, 55
Carthage, 16
cave paintings, 10-11
Charioteer rock paintings, 12-13
Chibinda Illunga, 37
Chokwe, 37
Christianity, 14, 26-27, 34-35, 38, 52, 55
cloth, 50-51
 adwinasa, 50-51
 asasia, 50
 kente, 50-51
coins, 26-27
Columbus, Christoper, 33, 54
Congo, 46
Cook, Captain James, 52
Coptic Egypt, 14, 15, 27
 art of, 14, 15, 27
cotton, 50, 54
Crowther, Samuel, 39
Cuba, 54-55

Dakar, 59
de Gama, Vasco, 33
Denkyira, 31
diamond mines, 53
Dinka, 13
Dinya heads, 17
divination, 36, 38-40
Dogon, 20, 42
 sculpture of, 20
Douglas, Aaron, 57

Aspects of Negro Life: An Idyll of the Deep South, 57
DuBois, W. E. B., 56-57
Dutch East India Company, 52
dyes, 50-51

earplugs, 49
Ecole des Beaux Arts, Dakar, 59
edan figures, 41
Edmonson, William, 55-56
 Crucifixion, 56
Edo people, 28
Egypt, 13-16, 27
 art of, 14-15, 27
Eid, 57
Elekole of Ikole, 41
embroidery, 15, 51
Enwonwu, Ben, 58
Ethiopia, 26-27, 53
Expressionism, 57

Fang art, 43
farming, 14, 16-17, 20-22, 31, 38, 44, 47, 54
Fatimids, art of, 15
festivals, 42, 58
 bago di (Mali), 42
 Eid, 58
fetishes, 35, 59
fossils, 10
France, 53-54, 57-59
Fuller, Meta Warwick, 57
 Ethiopia Awakening, 57

Gabon, 43
Ghana, 31, 54, 56
ginna bana, 42
gods and goddesses, 15, 20, 23-24, 26-27, 30-31, 38-44, 55
 Ala (Igbo), 43
 Amon (Egyptian), 15
 Amun (Meroe), 15
 Baron Samidi (Haitian), 55
 Eshu (Yoruba), 38-39, 55
 Ifa (Yoruba), 38, 40
 Ilmouqah (Axum), 27
 Isis (Egyptian), 15
 Khonsu (Meroe), 15
 Oduduwa (Ife), 24
 Oduduwa (Yoruba), 39
 Ogun (Yoruba), 38, 55
 Okun (Yoruba), 41
 Olorun (Ife), 24
 Oranmila (Yoruba), 38-39
 Orisan'la (Yoruba), 39
 Shango (Yoruba), 38-40, 55
 Xango (Cuban), 55
 Yemoja (Yoruba), 39, 55

gold, 20-21, 31-32
golden stool, 31
goldweights, 31
Gondar, 27
Great Britain, 31, 52-53, 59
Great Rift Valley, 10, 19, 26
Great Zimbabwe, 20-21
Greek Empire, 14-15, 27
 art of, 12-15
 Hellenistic style, 15
guilds, 21, 29-30

hairstyles, 17, 29, 48
Haiti, 54-55
Harlem, 56-57
 artists of, 56-67
Harlem Renaissance, 56-57
Hausa, 51
Henry, John, 57
Herodotus, 15
Heydon, Palmer, 57
Hodges, William, 52
Homo habilis, 11
Houtman, Cornelius, 52
Hungary, 37
hunter-gatherers, 10-12, 35, 37

ibeji figures, 40
icon, 27
Ife, 20, 22-25, 29, 38-39, 49
Igbo people, 22, 43
Igbo Ukwu, 22
 sculpture from, 23, 25
India, 21, 27
initiation ceremonies, 45-46, 49
international style in Africa, 58
irrigation, 14
Islam, 15, 32-33, 51
ivory, 22, 30, 32-34
ivory carving, 30, 33

Jenne, 19-20, 32
 sculpture at, 20, 32
jewelry, 17, 23, 25-26
Jews, 15
Johnson, William, 55, 57
 Going to Church, 55

Kalabari, 43
 screens, 43
Kalahari Desert, 52
Kano, 51, 58
Kasai River, 35, 37
Kerma pottery, 14
king's palace at Ikerre, 41
 carvings at, 41
Kongo, 33-34, 54
 art of, 34

Koran, 15, 32
Kot aPe, 36-37
Kuba, 34-37, 48-49, 51
 art of, 35
Kwele, 46

Lagos, 38
Lake Malawi, 52
Lake Victoria, 19
language, development of, 10, 33
Lawrence, Jacob, 57
 In a Free Government, the Security of Civil Rights Must Be the Same as That for Religious Rights. It Consists in the One Case in the Multiplicity of Interests and in the Other, in the Multiplicity of Sects, 57
Leakey, Louis, 10
Leakey, Mary, 10
Liberia, 42, 53
lineage systems, 41-44
Lion Temple of the Musawwarat, 15
 sculpture from, 15
Livingstone, David, 52
Locke, Alain, 57
lost wax casting (*cire perdue*), 22, 25
Luba, 34-35, 37
 art of, 35
Lweji, 37
Lyndenberg heads, 18-19

magic, 18, 25, 35-36
Mali, 32, 42, 50, 58
Mamluks, 15
Mandela, Nelson, 53
manillas, 34
Maroon Communities, 54
 art in, 54
masks, 19, 30, 44-47, 55
 Bamana, 44
 carnival, 55
 Dogon, 46
 egungun, 45
 epa, 47
 gon, 46
 hip masks, 30
 Lyndenberg heads as masks, 19
 Sande, 45
 Tyi Wara: 44
 war masks: 46
 women and: 45, 47
masquerades, 44-47, 55
 animal masquerades, 46
 egungun, 47
 gelede, 47

Massai, 13
mbari houses, 43
Mende, 45
Meroë, 15
 art of, 15
metalwork, 16-20, 22-26, 29-31, 33
migrations, 56-57
minkisi nkondi figures, 35
Minshall, Peter, 55
mintindi figures, 34
Mombasa, 33
monoliths, 21
mosques, 15, 32-33, 38
Murray, Kenneth, 59
Muslims, 38, 58

Nago, 54
Namibia, 11
Napata, 15
National Association for the Advancement of Colored People, 56
Nationalist Party, South Africa, 53
N'Daiye, Iba, 58
 La Ronde à Qui le Tour (The Round—Whose Turn Is It), 58
Ndebele, 51
ndop, 35-36, 49
the Netherlands, 28, 52, 54
 artists from, 28, 52
New Calabar, 43
"New Negro" movement, 57
nganga, 35
Niagra Movement, 56
Niger, 16
Nigeria, 17-19, 28-30, 38, 41, 43, 48-49, 51, 54, 58-59
 sculpture in, 17-18, 22-25
Niger River, 16, 20, 24, 43
Nile River, 14-16
Nok, 17-18
 sculpture, 17-18, 22-25
Nooms, Reiner, 52
Nuba, 49
Nubia, 14-16
nyoka, 51

Obembe of Efon Alaye, 39
Ogboni, 41
Olduvai Gorge, 10
Olowe of Ise, 41
Onabolu, Aina, 59
Oni, 24
Onobrakpeya, Bruce, 59
opon Ifa, 39
Orange Free State, 53
oral history, 36
Orisha (Yoruba gods), 38-41
Oshogbo *mbari* group, 58-59

Oyo, 40

Paleolithic period, 10
Palingkloof, 52
pastoralists, 12-13, 21
pictographs, 12
Piula, Trigo, 59
 Ta Télé (Your Television), 59
plantation system, 54, 57
Polly Street Art Centre, 53
portraits, 17, 24-25, 29, 31, 35, 55, 59
Portugal, 29, 33-34, 38, 52, 54
pottery, 14, 17-25
Ptolomy IV, 15

queen mothers, 29, 35

racism, 56
raffia, 50-52
rain forests, 19, 35, 37-38
Republic of South Africa, 53
Rhodes, Cecil, 53
Rodin, Auguste, 57
Roman Empire, 14, 26-27

Sahara Desert, 11-14, 16, 20, 22, 25, 32-33, 50, 54
Sahel, 16-17, 20, 32-33
saints, 55
Sakore mosque, 32
salt, 20, 23, 33
saltcellars, 33
San, 10, 12-13, 19, 52
 paintings, 10, 12, 52
Santore, Charles, 20
São Salvador (Mbanza Kongo), 34
scarification, 48-49
Senegal, 53, 58-59
Seneghor, Leopold, 59
shamanism, 13
Shayaam aMbul a Ngoong, 35, 37
Sherbo ivories, 33
Shouten, Walter, 52
Sierra Leone, 33, 45, 53
silk, 26, 50-51
silver, 26
skeletons, 55
slaves, 20, 22-23, 27, 32, 34, 38, 43, 54, 56-57
South Africa, 18-19, 49, 52-53
South America, 54-55
 Indians of, 54
Soweto, 53
spices, 32
Stanley, Henry Morton, 52
stelae, 27
stone age in Africa, 16, 39
stone carving, 10, 15, 17, 21, 34

Sudan, 49
Surinam, 54
Swahili, 32-33

Table Bay, 52
Table Mountain, 52
Tada bronzes, 24
Tall, Papa Ibra, 58
Tanzania, 34
Tassili rock paintings, 11-13
tattoos, 48
taxes, 28
tembo, 36
textiles, 15, 26, 50-51, 54
Timbuktu, 20, 32-33
Tiv, 49
tools, 10-11, 16-18, 20, 39-40
Torday, Emil, 37
trade, 13, 15, 20-22, 26, 29, 31-34, 39, 43, 50, 54
the Transvaal, 53
Trinidad artists, 55
Tshatsinde, Bernard M., 53
Twins Seven Seven, 58
 The Anti-Bird Ghost, 58
Tyi Wara, 44

Uhrobo, 59
Union of South Africa, 53
United States, 54-57
University of Ibadan, 59

Victoria Falls, 52
Visionary style, 55-56

weaving looms, 50
witchcraft, 45
woodcarving, 20, 35-36, 39-43, 45, 47, 49, 58
wool, 50
World War I, 57
World War II, 58
written language, 39
 Yoruba, 39

Yoruba, 22-25, 38-41, 44-45, 47-48, 54-55, 59
 art of, 22-25, 38-41, 47, 54-55, 59
 Oba of, 38
 written language of, 39

Zaire, 19, 34-35, 59
 art of, 59
Zaire River (Congo River), 34-35, 59
Zambia, 19, 34
Zanzibar, 33
Zaria, 59
Zimbabwe, 19
 sculpture of, 21
Zulus, 49